HOW TO TAKE GREAT **PHOTOGRAPHS** WITH A

FILM CAMERA

HOW TO TAKE GREAT **PHOTOGRAPHS** WITH A
FILM CAMERA

 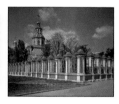 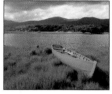

A PRACTICAL GUIDE TO THE TECHNIQUES OF FILM PHOTOGRAPHY,
SHOWN IN OVER 400 STEP-BY-STEP EXAMPLES

JOHN FREEMAN

LORENZ BOOKS

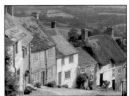

This edition is published by Lorenz Books,
an imprint of Anness Publishing Ltd,
108 Great Russell Street,
London WC1B 3NA;
info@anness.com

www.lorenzbooks.com;
www.annesspublishing.com;
twitter: @Anness_Books

A CIP catalogue record for this book
is available from the British Library.

Publisher: Joanna Lorenz
Senior Editor: Felicity Forster
Photographer: John Freeman
Additional text: Steve Luck
Additional images: Corbis 13t; Fotosearch 30–1;
iStock 8–9, 64–5, 102–3, 140–1, endpapers
Production Controller: Pirong Wang

PUBLISHER'S NOTE
Although the advice and information in this book are believed to be accurate and true at the
time of going to press, neither the authors nor the publisher can accept any legal responsibility
or liability for any errors or omissions that may have been made nor for any inaccuracies nor for
any loss, harm or injury that comes about from following instructions or advice in this book.

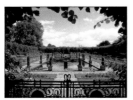

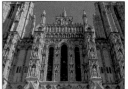

CONTENTS

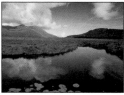

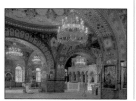

INTRODUCTION

There's no denying that today's camera phones and compact digital cameras have made the taking and sharing of images far more instantenous and ubiquitous compared with the days of film cameras. Although for a while keen amateurs and professional photographers always turned to film when image quality was paramount, advances in sensor technology have given rise to digital cameras that can resolve as much detail as traditional medium format film cameras, with the result that today the vast majority of professional photographers now shoot digitally.

But film is far from dead. In fact, there has been a recent resurgence of interest in film for a number of reasons. First off is the cost of used film camera equipment. A quick look on any internet auction site will turn up all manner of professional film equipment – cameras and lenses – for a fraction of the cost of comparable digital gear. Potentially enough to offset the cost of developing hundreds of film rolls. Secondly, film responds to light in a different way to imaging sensors, and can in certain circumstances produce results that differ quite noticeably from digital images – not necessarily better, just different.

Finally, and perhaps most importantly, using film tends to restrict the number of shots you take. This leads to a slower, more considered approach to photography. Rather than firing off tens of shots of the same subject in the expectation that at least one will work, when shooting film many photographers find they take greater care over elements such as composition, exposure and lighting. It may be for this reason that many of the schools and colleges that offer photography courses still teach students how to use a film camera and how to develop and process film and make prints. Going back to traditional film photography, even if not necessarily exclusively, may just help to reinforce the fundamentals of photography.

● BELOW This photograph of the Coliseum in Rome strikes a perfect balance between the illumination of the stone of the building and the colour of the twilight sky. The trails of the head- and tail-lights of the traffic help to fill the void created by the road.

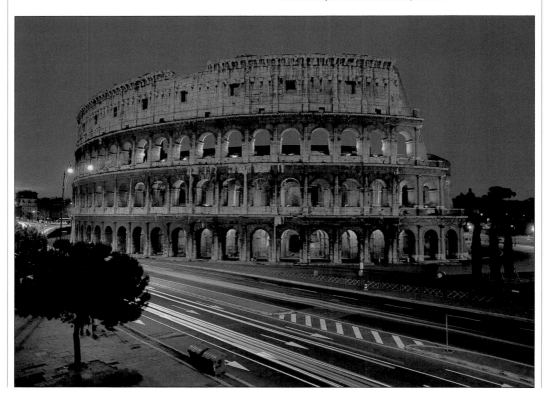

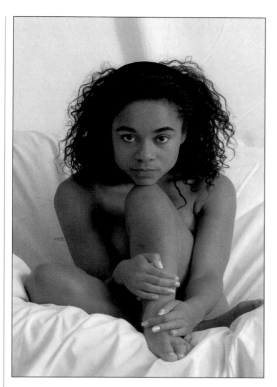

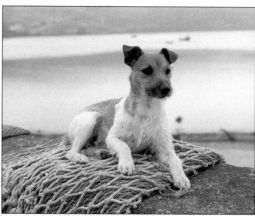

● LEFT This picture shows what can be done in the home. A length of white cotton material was pinned to the wall and draped over a sofa. One flash was used, fitted with a large diffuser called a softbox. This was powerful enough to illuminate both the girl and the background. Some people – both photographers and models – find it less intimidating to work in an ordinary home than in a professional photographic studio. But as confidence and adventurousness increase, an improvised home studio can become a restriction, unless of course the room is very large.

● ABOVE This dog looks alert and the fishing net makes an interesting prop. Autofocus and TTL exposure metering will help you to work quickly when photographing pets.

● BELOW This photograph shows what can be achieved with a zoom lens. The lens has been moved from 80mm to 300mm, so it looks as if the boy is going around a corner at speed.

IN THIS BOOK

Getting Started with Film provides a quick rundown of the types of film camera that can still be found today, and looks at their individual strengths and weaknesses. Also discussed are lenses, with particular emphasis on interchangeable lenses for SLR cameras and their primary uses. Following advice on accessories that can help improve your photography and how to look after your equipment, the section finishes with an introduction into film, both colour and black and white, and why certain types of film are more suited to specific subjects.
Photography Techniques explains the core concepts of photography, including aperture and shutter speed settings, exposure, focusing, key elements of composition, and how to use flash. This section explores in more detail how lenses of different focal lengths are used to photograph a diverse range of subjects, including portraits, landscapes and buildings.
The next two sections, **Landscape and Travel Photography** and **Photographing People**, provide insight into how to create stunning images within these popular photographic genres. The combination of powerful imagery and explanatory, accessible text will help you to think about how to set about photographing your favourite subjects.
The final section on **Processing and Printing** tells you everything you need to know about processing film and how to make photographic prints, the equipment you will need and the techniques to employ.

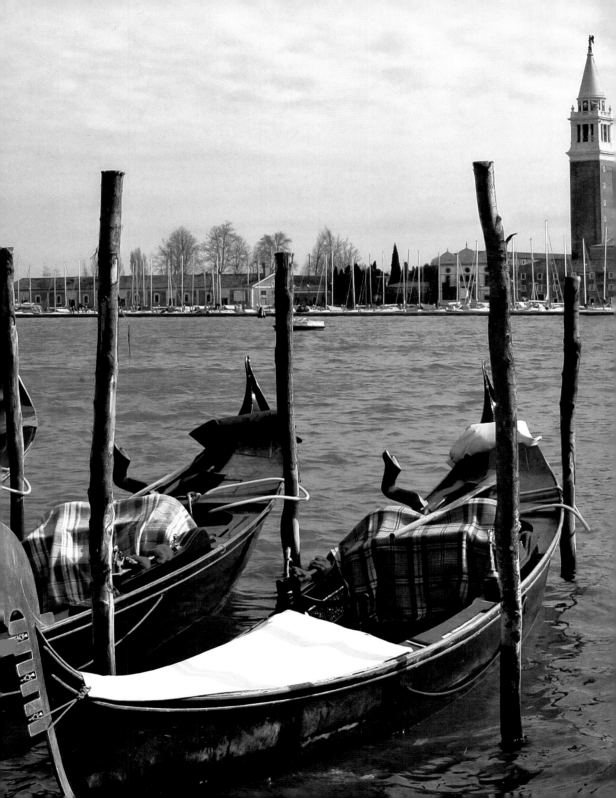

GETTING STARTED
WITH FILM

● LEFT A good understanding of camera equipment and accessories is the first step in getting outstanding results, such as this beautiful photograph of Venice. A few simple basics and a good eye are all that is needed to get the best out of photography – whether it is around the corner or halfway around the world.

Whether shooting with film or digitally, the question that professional photographers are probably asked most frequently is, 'What is the best camera I can buy?' Unfortunately there is no simple answer. Even though many people consider the Rolls-Royce to be the best motor car in the world, it is not suited to all uses: it would be at a distinct disadvantage in a Formula One race, for example. In the same way, there are some cameras that some photographers consider the 'Rolls-Royce' of their kind, yet it does not always follow that these are the best choices for all shooting situations. Undoubtedly the camera that historically has proved most popular for film users is the 35mm SLR.

The important aspects to consider when choosing a camera are application, variety of accessories and cost. The range of cameras available is still wide, yet each type is very distinct in its uses. Photographers should examine the different models and decide which might be the most suitable for their requirements. Ultimately, however, whichever camera is used, the elements

that go to make up the final image will be those that the photographer brings to the camera, rather than the number of dials, buttons, functions or modes it has. Even a disposable camera can produce a good picture in the hands of an attentive and enthusiastic photographer who takes care with composition, gives thought to the foreground and background, and notes the prevailing lighting conditions.

Great shots can be achieved with even the most modest budget and a little technical knowledge. The more money the photographer is prepared to spend, generally the more sophisticated the camera can be; usually the higher rated models will include autofocus, motor drives, an extensive menu system with different functions and a more sophisticated metering system to measure the light and help you choose, or select itself, the correct exposure. This is not always the case, though, and some of the more expensive cameras available are in fact the simplest, giving incredible strength, reliability and user-friendliness. The more expensive models obviously expand the creative

possibilities of the 35mm camera, although even the basic models are reliable and will produce effective shots.

35MM CAMERA

Before the arrival of inexpensive portable digital cameras and camera phones, the compact 35mm camera (so-called because it uses 35mm film) was the camera of choice for those who wanted, with the push of a button, snapshots of holidays, birthdays and other similar events. Although this type of camera is no longer in production, the used market is plentiful, and most of these cameras, especially the better ones, will still work just as well today as they ever did. The simplest and cheapest will be a 'point-and-shoot' version without a built-in exposure meter or flash, where the film is loaded and advanced manually. The more complicated will normally have the automation of the simple model, but also contain more features such as manual exposure, manual focus, spot metering and the like. However, with pre-owned film SLRs (see below) now readily available at really affordable

● BELOW Kit such as this Nikon 35mm SLR may look dated and even retro today, but it still works well and is much loved by many photographers. Many used-equipment stockists will let you 'test drive' models.

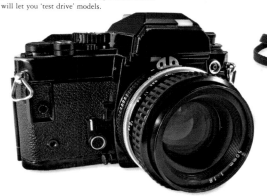

● ABOVE With the advent of the compact camera came a photography revolution. Suddenly, millions of people could afford an easy-to-operate camera and keep visual records of their lives. Today, 35mm compacts have been eclipsed by digital compacts and camera phones for the masses, and film enthusiasts and professionals are more likely to use SLRs or medium format cameras.

prices, if you're looking to explore what film has to offer as an alternative to digital, then this type of camera will provide you with much greater flexibility and versatility when compared with a 35mm compact camera, together with much better image quality thanks primarily to higher quality lenses.

Single Lens Reflex (SLR) Camera

This camera is portable and extremely adaptable. Since its introduction in the 1940s, the single lens reflex (SLR) has proved to be one of the most popular cameras available. The original design evolved into a multiplicity of models, the majority of which have quite a formidable array of lenses, filters and other accessories.

When you look through the viewfinder of an SLR camera, what you see is what the lens 'sees'. This is

because there is a mirror behind the lens that reflects the image up to a device called a pentaprism. This turns the image the right way up and the correct way round, and is situated on the top of the camera in front of the viewfinder. In normal conditions, when the shutter release button is pressed, several functions operate in a fraction of a second. First, the mirror flips up 45 degrees so that light can pass through the lens on to the film. The aperture you have chosen stops down. The focal plane shutter opens for the amount of time you have chosen on the shutter speed dial and then closes, then the aperture opens up to its full extent and the mirror comes back down so that you can view the scene again.

Using available 35mm film, the basic SLR model can be adapted by the addition of all sorts of equipment, including telephoto or zoom lenses,

motor drive and flash units. This means that it is the ideal 'system' camera; it can be adapted as quickly or as slowly as budget allows.

Today, although very few 35mm SLRs are available new, the cost to buy a top-quality second-hand camera containing the specification that you choose is low, and certainly less expensive than many comparative digital versions. Modern and older models, from companies such as Nikon, Canon, Pentax and Olympus, are great value today if you choose to shoot with film.

Rangefinder Camera

This is another model of camera that has proved very popular with professional photographers over the years. The most famous brand of rangefinder is the Leica, although models by Zeiss and Voightlander are also available second-hand. The French

● LEFT When shooting with a rangefinder camera, such as this 1970s model, you look through a viewfinder rather than through the lens. You line up the images seen through the viewfinder and the lens to get a sharp image, then shoot.

● BELOW Nikon's F6 began production in 2004, and it is still produced today. It introduced many new technologies to the film format. For example, the engineers reduced the vibrations associated with film operation.

photojournalist Henri Cartier-Bresson shot nearly all his most memorable pictures using one.

In contrast to the SLR camera, the rangefinder allows the subject to be seen through a separate viewfinder rather than through the lens. In the centre of the viewfinder are two images. When the lens is focused on the subject, these two images become aligned with one another and the picture will then be sharp. This method of working is preferred by some photographers who find that the camera is quieter to operate and is less prone to being affected by vibration because there is no mirror to flip up. Although the rangefinder does not have quite as wide a range of accessories as the SLR, it is a sturdy and reliable camera with extremely high-quality lenses. The rangefinder is available in 35mm or medium format models.

The digital revolution has been slower to affect rangefinder cameras, and there are far fewer digital rangefinders available than digital SLRs. Fifteen years

after Nikon introduced the D1, the first truly professional digital SLR, there are still only a handful of digital rangefinders available, all made by Leica.

For years, professional photographers, including those shooting for the world-famous picture agency Magnum, used film-based rangefinders because they provided exactly what was needed: reliability and speed, with very few electronic components. In fact, early Leica models, originally made in the 1960s, are still very popular today. The most popular medium format film rangefinder camera, the Mamiya 7 was an updated version of the Mamiya 6 and was favoured by many travel photographers because it combined the essential qualities of size, weight, fantastic lenses and the superior image quality of the larger medium format film.

SLR Medium Format Camera

These cameras come between the 35mm and the large format cameras in size and application. They take pictures in a variety of formats, including 6 × 4.5cm, 6 × 6cm, and 6 × 7cm. These cameras have extensive ranges of lenses and

accessories, and are still much favoured by professional photographers shooting both film and digital – many of these cameras have the ability to take both a film back and a digital back. These cameras are in general made up of three main parts: the lens, the body and the back. The back contains the 120 (or less commonly 220) roll film, or can be swapped for a digital back where wanted. They are bulkier than 35mm SLR cameras.

Although they are often used on a tripod, SLR medium format cameras are also extensively used hand-held by fashion and portrait photographers. Today, although some manufacturers of medium format cameras are no longer in existence – such as Bronica and Contax, for example – other companies, including Hasselblad and Mamiya Leaf, are still thriving. As with the 35mm film camera, many second-hand models of medium format SLRs will work today as well as ever, with many older versions of the Hasselblad, Contax or Mamiya camera system being widely available from your local stockist.

5 x 4 Camera

This is a large format, tripod mounted camera which takes photographs where the transparencies or negatives are 5 × 4in (13 × 10cm). The film can be loaded into double dark slides, each one holding just two sheets. Film known as quickload or readyload was also available, where each sheet came in an individual package and a special quickload or readyload holder was used

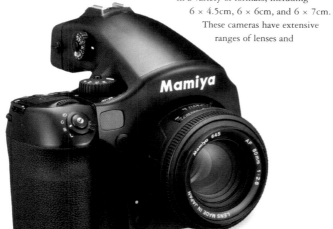

● LEFT Mamiya produced a range of film-back medium format cameras, such as this 645 afdII autofocus SLR medium format camera, that were used widely by professional photographers. If you are looking for a film camera, don't rule out second-hand models, because they still create great images.

● RIGHT Holga cameras, originally developed as toy cameras, have grown a following over the years. They offer an alternative to the crisp, colour-faithful images of digital cameras.

instead of a double dark slide. There is no viewfinder in the conventional sense: the image is seen upside-down and back-to-front on a ground glass screen. In order to see the image and keep out any stray light, the photographer covers the camera and his head with a dark cloth. Despite the rather old-fashioned appearance of the camera, many models are extremely sophisticated, and they can be expensive.

The range of applications of the 5 × 4 camera is very varied both in the studio and on location. It produces pictures with excellent clarity and sharpness of detail. However, it would not be the best choice for spontaneous and fast action shots, where a more portable camera with quick shooting capability might be more suitable. These cameras are also available in 10 × 8in (26 × 20cm) and even up to 24 × 20in (60 × 52cm), with other sizes in between.

INSTANT AND 'LO-FI' CAMERAS

Although not as popular now as they were in the days of Polaroid cameras, instant cameras are still available, notably Fujifilm's Instax range and those made by LOMO. These cameras offer another dimension to picture-taking. After the picture is taken, the

● RIGHT Hasselblad's iconic 503CW medium format SLR. The film can be hand-cranked or moved on by remote control. It is ergonomically designed to be hand-held in comfort. Hasselblad lenses are made by Carl Zeiss, a world leader in optics manufacture, and they give great results.

film is impregnated with the chemicals required for processing the image, and the picture begins to appear just seconds after the shutter is pressed; development is complete within minutes. As well as providing an immediate image of the subject, these cameras also offer as many possibilities for creative photography as their conventional counterparts.

LOMO, along with the Hong Kong company Holga, have grown an enthusiastic following for their so-called 'lo-fi'cameras. Little more than toy cameras, they are cheap to produce, often have plastic lenses, and light can leak to the film. The results are often magical and surreal, offering creative possibilities in a pleasingly hit-or-miss fashion.

Just as there is no one camera that is ideal for every shooting situation, the same is true of lenses. Some lenses in certain situations have distinct advantages over others. An extra element of challenge can be added to photography by experimentation with different lenses, perhaps applying a certain lens to a situation in which it is not normally used.

LENS MOUNTS

All SLR cameras have interchangeable lenses, attached to the camera by means of a mount. There are several different sorts of mount, the most popular being the bayonet mount. This is operated by depressing or sliding a small button positioned on the camera body near the lens. The lens can then be turned 45 degrees in a clockwise direction and pulled gently forward from the camera body, and another lens inserted using the reverse procedure.

CHOICE OF LENSES

Interchangeability of lenses opens up a vast array of options, and is probably the biggest single factor in improving photographic creativity. Lenses for 35mm cameras come as either a prime lens or a zoom lens. The prime lens has a fixed focal length, such as 28mm, 50mm or 135mm; and a zoom lens has variable focal length in one lens, such as a 17–40mm lens or a 24–105mm lens. The benefits of a prime lens are the highest possible image quality; often a

● BELOW A selection of mainly professional 'L' series Canon lenses. Although lens mounts have changed over the years, Canon's EF mount, which is still used today was introduced in 1987. You may find that modern lenses such as these, which have improved optics and other advantages such as image stabilization, will fit your old 35mm SLR camera.

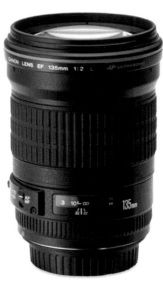

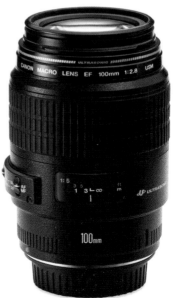

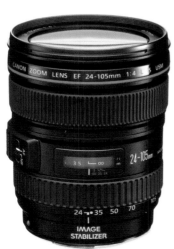

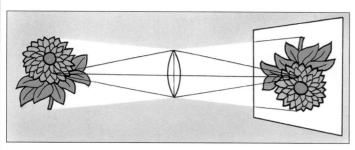

● ABOVE The subject is reproduced through a lens upside-down on the film.

larger maximum aperture (known as a faster lens) which means better low-light shooting and a shallower depth of field, which can be very useful in portraiture especially; and they are fairly small and discreet. Usually, though, you will want to carry at least three prime lenses with you to cover the range of focal lengths. Most new prime lenses made today are autofocus, but still offer the option to focus manually, but there are also some very high-quality manual focus prime lenses being made, and many older lenses will also still produce outstanding results.

A zoom is very practical in that one lens will often cover the focal length of three prime lenses. They are, however, generally larger in size and in many cases the pure image quality is not as high as a prime, and the distortion may be greater.

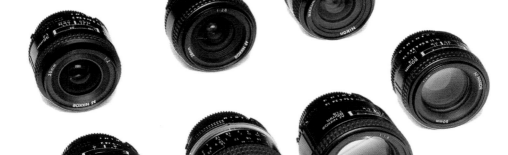

● ABOVE Lenses that are no longer compatible with modern digital cameras, due to old mounts, are often inexpensive. Although cheap to buy, the optical quality of old lenses can still be excellent.

On the other hand, some of the latest zoom lenses do offer an image quality equal to that of a prime lens at certain focal lengths. All zoom lenses being made today are autofocus, but will also still offer the option to focus manually.

WIDE-ANGLE LENS

A wide-angle lens (14mm to 35mm) gives a wider angle of view, so more of the area in front of the camera will appear in the shot. Like any piece of equipment, there are disadvantages as well as benefits; the most common in the case of the wide-angle lens occurs with landscape photography where the foreground may lack interest so the eye is not naturally led to the central point of the picture.

On the other hand, using a wide-angle lens does allow subjects to be photographed much closer to the lens than usual, while at the same time keeping the background in focus. In some cases this effect can greatly enhance a composition.

STANDARD LENS (50MM)

This focal length will give an angle of view roughly equivalent to what we see with our own eyes. Standard lenses are generally small in size, with a large maximum aperture of 2.8, 1.8 or 1.4.

TELEPHOTO LENSES (70MM TO 800MM)

A medium telephoto lens has many advantages. As well as bringing distant objects closer, it is a superb lens for portraits. It has definite advantages over a wide-angle lens in this situation as, when used straight on to a person's face, a wide-angle lens will add an unflattering, albeit at times amusing quality. A telephoto lens in the region of 100mm enables the photographer

to stand some distance away, making the subject more relaxed and allowing an unblocked light source. The lens will very slightly compress the image, making for a far more pleasing portrait. The depth of field will be less, so the

● BELOW When you photograph a tall building, it is sometimes necessary to point the camera upwards to get all the building in the frame. This will cause converging verticals, which means the sides of the building will appear to taper in towards the top. Using a shift lens enables you to keep the vertical sides of a building parallel, while keeping the whole of the building in the shot.

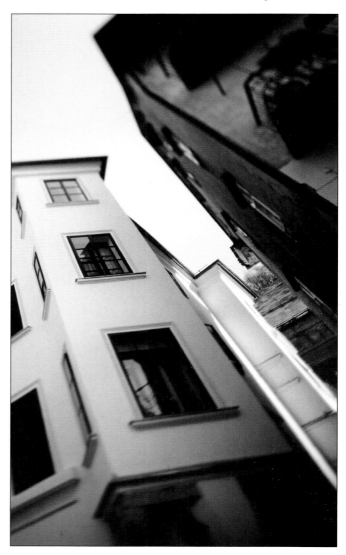

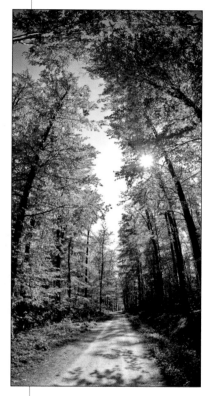

the top of the picture. The conventional rule for preventing this from happening is to ensure that the film plane is parallel to the vertical plane of the subject, and then all vertical lines will remain straight in the final shot. However, with a fixed lens the top of a very tall subject is usually cut off, but with a shift lens the axis can be altered, allowing the camera to remain straight while the lens is moved upwards: the top of the building will then come into view.

Some shift lenses also allow you to tilt the lens, which means you can alter the plane of focus for very creative possibilities, such as producing pictures of cityscapes that look like toys, portraits where only very small sections of the face are in focus at seemingly impossible angles, or as in the case of product and macro photography, getting all the product in focus even when using very close focus with the camera and lens at an angle to the subject matter.

FISHEYE LENS

This lens can be used to dramatic effect, but as an everyday piece of equipment it has limited applications and its novelty value can soon wear off.

MACRO LENS

This allows the photographer to get very close to the subject without the need for special close-up attachments on the camera. Depending on the lens used, small objects can be magnified to produce a final print that shows them life-size. Many of the lenses in the 28–300mm range have this facility built in, and it is often worth considering paying a bit extra at the outset if macro photography is of interest. Certainly, if you are thinking of nature or abstract photography, you should be interested in macro effects.

● BELOW Macro lenses allow you to obtain excellent quality close-up shots. They're ideal for nature images, but due to the magnification it is very hard to keep everything in focus.

● ABOVE A fisheye lens has produced this shot, where the trees look as if they are bending protectively over the path.

background can be put out of focus and a part of the subject's face, such as the eyes, can be highlighted. Very long telephoto lenses from 200mm and above will allow you to get even closer to the action, and these are invaluable in sports and wildlife photography.

SHIFT/TILT LENS

The shift or perspective control lens allows photography of a subject that is very tall, without the problem of converging verticals; this occurs when the sides of the subject taper in towards

GETTING STARTED WITH FILM

There are many accessories that can
be added to a basic camera unit when
building up a comprehensive 'system'.
It is important to bear in mind
that no accessory on its own is going
to provide a magic formula for
improving photographic skills.
Accessories lend technical help,
yet it is the photographer's eye for
seeing a good picture that is the
essence of photography.

Accessories are important, as
they can take your photographs to that
next step in terms of technical expertise.
You will find that your equipment
allows you to create photographs that
match your vision. With only basic
or amateur kit, you will not be able to
attain this. Your local camera stockist
should be able to talk to you about
the kind of kit you need, and help
you make some wise investments
according to your needs.

UV Filter
Having decided on and purchased the
camera, the next thing to buy is a UV
filter. This can be kept on the lens at
all times, whether you are using colour
or black and white film. As well as
reducing the amount of ultraviolet light

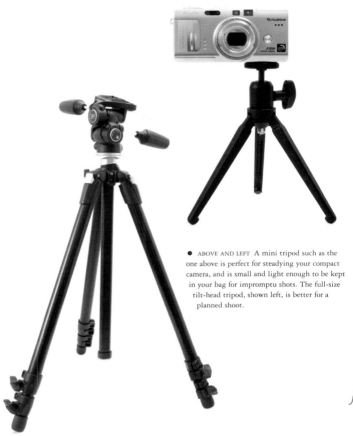

● ABOVE AND LEFT A mini tripod such as the
one above is perfect for steadying your compact
camera, and is small and light enough to be kept
in your bag for impromptu shots. The full-size
tilt-head tripod, shown left, is better for a
planned shoot.

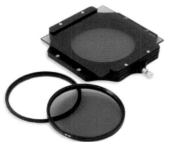

● ABOVE Filters can be round screw-ins or
squares that drop into a filter holder on the
front of the camera lens.

passing through the lens (cutting down
haze and minimizing the risk of a blue
cast appearing on the film), it will also
protect the lens itself. It is much
cheaper to replace even a good-quality
glass filter if it gets scratched than a
scratched lens. Consider buying a UV
filter for each lens.

As well as the UV filter, there is a
whole selection of special filters and
holders available. These range from
colour correction and colour-balancing
filters to special effect filters and masks.

Lens Hood
This should be bought at the same time
as the camera. Look at any picture of
professional photographers at work and
they will all be using lens hoods. The
hood prevents most stray light from
entering the lens. Stray light causes
flare and can ruin the picture. It may
be caused by sunlight falling directly
into the lens or being reflected off a
building or shiny surface. If you are in
any doubt as to the necessity of a lens
hood, next time you are walking or

driving into the sun, notice how you need to shield your eyes from the light with a hand or the sun visor in the car. A lens hood works in exactly the same way for the camera lens.

TRIPOD

This keeps the camera steady during shooting at long exposures. To be effective, the tripod must be rigid. Some tripods are very flimsy when fully extended, so it is often well worth paying a little extra money for a truly sturdy model. Tripods are available in many sizes, from the smallest, which are about 15cm (6in) high, to much larger, heavy-duty models which can extend to well over 3m (10ft).

Some tripods come complete with all attachments; others need a head, the part that fixes the camera to the tripod. Heads can vary, and it is important to look at several before making a final choice. The most common type is the 'pan and tilt' head which allows the

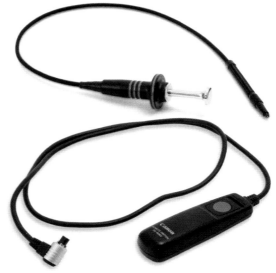

camera to be moved smoothly through 360 degrees – the 'pan' movement. At the same time it can be adjusted vertically; this is usually in the range of 90 degrees forwards and 45 degrees backwards – this is the 'tilt' movement. (If an angle of 45 degrees is not sufficient, turn the camera around and use the head back-to-front.)

● LEFT The ball head gives you easy control of a camera mounted on a tripod.

● BELOW A monopod is perfect for sports events, as it allows you to follow the action but keeps your camera steady enough for great shots.

● ABOVE The shutter release cable allows for vibration-free shooting on a tripod, and thus gives you sharper pictures. The top cable is for traditional film-back cameras; the lower is for digital cameras.

Another useful head is the 'ball and socket' version. Normally this has two knobs that allow the camera to be moved when fixed to the tripod in much the same direction as the pan and tilt head, yet is far less cumbersome.

MONOPOD

Since many tripods are often bulky, some places such as churches, buildings of historical interest and museums do not allow their use without a permit. One solution to this may be to use a monopod. As its name suggests, it consists of a single leg which can be adjusted to different heights. Obviously a monopod will not stand unaided, but it can be used to help brace the camera. Professional photographers at a football match, for example, nearly always use a monopod.

CABLE RELEASE

A cable release can be attached to any camera, which allows it to be screwed into the shutter release button; when

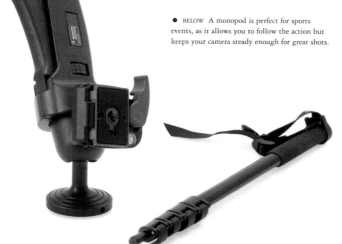

the plunger on the end of the cable is depressed it fires the shutter without the need for any direct manual contact. It is often used in conjunction with a tripod when shooting at slow speeds to reduce the vibration that often occurs when the shutter is released manually.

Some cable releases are now available for SLR cameras. When the cable is depressed halfway, the mirror-up mechanism is activated. Any vibration that occurs when the mirror goes up is then eliminated by this intermediate stage in the shutter release process. When the cable plunger is depressed fully, the shutter is fired and the camera remains steady.

CARRYING CASE

A case to carry all the accessories is convenient and also provides protection for equipment. The most effective cases have hard outer shells with compartments moulded from foam rubber to hold the individual accessories. Soft cases are also available, but these may not be suitable for very delicate items. Many cases are obviously meant for carrying cameras; this attracts thieves, so do lock them out of sight if left in a car. Insuring expensive photographic equipment is becoming increasingly costly; if you think that you may have to leave equipment in a locked vehicle, make sure that the insurance policy covers theft from cars.

FLASH ATTACHMENTS

Most SLR cameras do not have built-in flash, so it is certainly worth purchasing a flash unit to attach to the 'hot shoe' or accessory shoe on the camera. Some are quite compact, but are nevertheless sophisticated and powerful.

The more powerful flash units are mounted on a bracket that is screwed into the base plate of the camera, and

● TOP A soft, discreet shoulder bag is perfect for photojournalist work.

● MIDDLE A hard case gives great protection. Inside are padded inserts to keep all your kit secure.

● BOTTOM Rucksack-style bags are suitable when your job will involve a lot of walking, and speed of access is not of paramount importance.

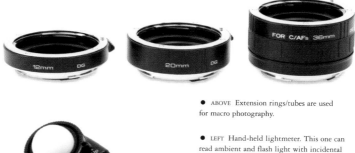

linked to the flash synchronization socket on the camera by means of a cable. When the shutter is activated, a signal is sent to fire the flash.

EXPOSURE METERS

Although most cameras now have some sort of built-in mechanism for evaluating exposure, a separate hand-held exposure meter is very useful. Basic photoelectric meters need no batteries and register the amount of light available. Although reliable, they are not as powerful nor as sensitive as the battery-powered meters; many of these can be used as flash meters as well as for reading ambient light.

In ambient light mode, they can be used to take incident light readings as well as reflected light readings. An incident light reading is taken when the meter is placed on or near the subject and pointed towards the light source to take a reading. A reflected light reading is taken when the meter is directed at the subject from the camera position. It will take a little practice to be able to evaluate the various benefits of the different types of reading.

● ABOVE Extension rings/tubes are used for macro photography.

● LEFT Hand-held lightmeter. This one can read ambient and flash light with incidental reflection and spot metering.

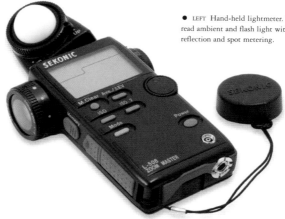

EXTENSION RINGS OR BELLOWS

These are used in conjunction with SLR cameras and allow close-up photography of detail in stunning clarity. Close-up lenses can be used for the same purpose, but extension rings give a far better result.

The rings or bellows are attached to the body of the camera on the lens mounting; the lens is then attached to the front of these. The rings offer a single magnification, whereas with the bellows the magnification is variable.

● BELOW Photography kit has changed in its appearance and capabilities over the years, as these old cameras and flashes illustrate. 'Old' kit may not necessarily be outdated, however, and it is worth looking at the used section of kit in your camera stockist.

Cameras and lenses are delicate and expensive instruments that need to be treated with care. Water, dust, dirt and grit are the worst enemies, although leaving a camera in bright sunlight or in the glove compartment of a car will not do it any good either, and so any strong heat should be avoided.

Wrapping the camera in aluminium foil is one solution. If the camera is taken to a sandy beach, keep it wrapped in a plastic bag when not in use. Even on the calmest days sand seems to get into every crack; extra care needs to be taken as sand can easily ruin expensive equipment. It is possible to buy a waterproof cover that attaches to the bottom of the lens and allows you to operate the camera through the material. This would be useful for

protecting your camera if you are taking it to a beach or some other potentially wet or dusty environment for a shoot.

When a camera is not in use, it should be kept in its case or together with the other pieces of equipment in a proper camera bag away from any source of heat such as a radiator. If the camera is not going to be used for some time, the batteries should be removed; if left in the camera, the acid may corrode the contacts and cause irreparable damage. If you use film, keep it cool – even refrigerated – if possible to retain its quality.

LENSES AND FILTERS
Always keep a skylight UV filter on the lenses. This will keep out UV light and will help protect the lenses themselves.

This filter can be kept on the lenses permanently, with either colour or black and white film. A scratched filter is cheaper to replace than a damaged lens.

If the filter or lens becomes dirty, first blow away the dust and any other particles of dirt. The most efficient way of doing this is to use a pressurized can of air. Alternatively, use a soft brush with a blower attached to it. If neither of these pieces of equipment is available, simply blow gently on to the surface. The next stage is to remove any grease by gently wiping the lens or filter with a soft tissue or lens cloth. You may or may not need cleaning solution. Do not use regular household

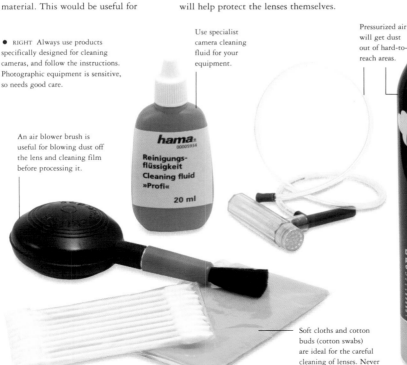

● RIGHT Always use products specifically designed for cleaning cameras, and follow the instructions. Photographic equipment is sensitive, so needs good care.

Use specialist camera cleaning fluid for your equipment.

Pressurized air will get dust out of hard-to-reach areas.

An air blower brush is useful for blowing dust off the lens and cleaning film before processing it.

hama.
00005934
Reinigungs-flüssigkeit
Cleaning fluid »Profi«
20 ml

Kenair
Air Duster
CFC FREE
Dust remover for photographic, domestic, office or laboratory use

Soft cloths and cotton buds (cotton swabs) are ideal for the careful cleaning of lenses. Never touch the camera sensor.

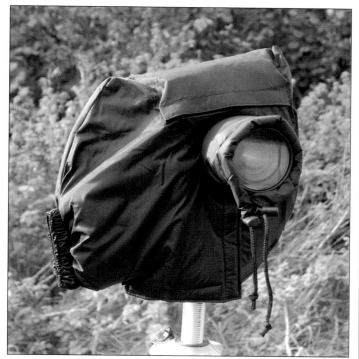

● ABOVE Always keep a lens cap or UV filter on your camera, because replacing a damaged lens is very expensive.

cleaning products or any unspecialized equipment on your camera. It is not worth the risk.

BROKEN EQUIPMENT

If something jams in or on the camera and the fault is not apparent, never force the piece, as more serious damage could be caused. If the lens or camera develops a serious fault, send it to a reputable camera repair shop. If it is under guarantee, return it to the

dealer or direct to the manufacturer. It is certainly unwise to fiddle with the camera sensor in any way. Anything beyond day-to-day maintenance should be left in the hands of experts. If you are not sure about maintenance and repair issues, staff in your local camera stockist will be able to advise you on the best course of action.

● ABOVE Some camera covers are available that are insulated as well as waterproof, which may be particularly useful in the winter. Holes at the sides allow you to slip your hands in and operate the controls, and perspex or clear plastic windows at the back allow you to see the screen, if using a digital SLR.

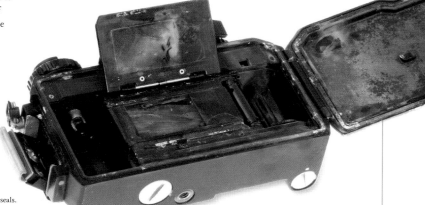

● RIGHT This underwater camera has been damaged by water leaking in through faulty seals. In cases like this, cleaning will not help, and unfortunately the camera must be thrown away.

At first, when confronted with the mysterious numbers and words on film canisters, it can be confusing. It won't be long before you know what you need, however. There are two main types of colour film used.

• Colour reversal film produces transparencies that can be mounted as slides and projected or viewed with a slide viewer or on a light box. Transparencies can also be made into prints, either directly, or from what is called an internegative, which involves photographing the transparency on to the other kind of film, colour negative film. Of course, transparencies can also be scanned and digitally printed.

• Colour negative film is the type used to make prints. Colour negative is simple to use, as it is easy to get processed and have prints made. Both types of film come in a full range of sizes, from 35mm to

10 × 8in (26 × 20cm) sheet film. They also come in various speeds. These are given as an ISO (International Standards Organization) number from about 25 for the slowest up to 1600 and beyond for the fastest. The slower the film, the finer the grain and sharpness, and the greater the colour saturation and contrast. 1600 ISO film can be uprated to 3200 ISO and more for work in low light, but the result will be very grainy – an effect which may be sought out.

*U*PRATING *F*ILM AND *DX* CODING

Uprating, also called speed readjustment, means using film as if it had a higher ISO rating than it actually does, and thus shortening exposure time. Uprated film needs a longer development time, and if you uprate any film you must let the laboratory know that you have done this so that they

can 'push', or extend, development. Some laboratories charge extra for handling uprated film.

Many 35mm film are DX coded: this means that the film cassette has a barcode on it. Many recent film cameras have sensors that read the code and change the camera's ISO setting to the appropriate speed automatically. Using your camera's exposure compensating dial, you can adjust this to uprate the film.

*L*IGHTING

There are two types of colour film: one for daylight and electronic flash; the other for tungsten light (ordinary lamps). If daylight film is used in tungsten light, the shots will come out very warm, with an orange and red glow to them. If tungsten-balanced film is used in daylight, the pictures will have a blue cast. Although both of these films are made for the specified lighting conditions, there is no reason why they should not be used in different lighting to create a special effect. Either of them can also be used with a light-balancing

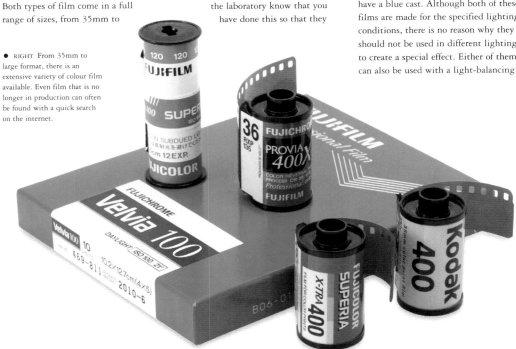

● RIGHT From 35mm to large format, there is an extensive variety of colour film available. Even film that is no longer in production can often be found with a quick search on the internet.

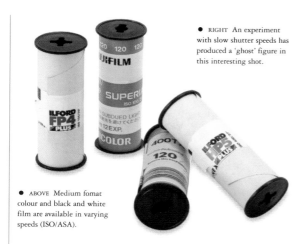

● ABOVE Medium fomat colour and black and white film are available in varying speeds (ISO/ASA).

● RIGHT An experiment with slow shutter speeds has produced a 'ghost' figure in this interesting shot.

filter. Using an 85B filter, which looks orange, on a camera allows tungsten film to be used in daylight or with electronic flash to get a normal colour balance. An 80B filter, which is bluish, allows daylight film to be used in tungsten film with normal results.

ACCURATE EXPOSURE

Exposure needs to be far more accurate for colour reversal film than for colour negative because the transparency is the final result. With colour negative film, any inaccuracies in the negative can be corrected at the print stage. It is a great help to make a test with an instant film so that any adjustments necessary can be made on the spot.

INFRARED FILM

You might also like to experiment with infrared film. This gives unusual although unpredictable results, quite different from the colours we normally see. For example, foliage becomes magenta, and pale skin tones green.

BLACK AND WHITE

Although shooting in colour has become the norm in photography, many amateurs and professionals still like to shoot in black and white. Some of the best-known photographers, such as Steven Miesels, Herb Ritts, Ansel Adams and Robert Mapplethorpe, have been famous for their work in black and

white, and exhibitions and books of their work consist almost entirely of beautiful black and white prints.

Undoubtedly most people relate immediately to a colour photograph, which is hardly surprising, since we see the world in colour. Therefore, any colour image is relatively acceptable, while an image in black and white has to be spot on for it to get the attention it deserves.

One reason for the decline of black and white film among most amateur photographers is that it is generally more expensive to process and get true black and white prints from than with

colour. It also takes longer to process. However, there is a type of black and white film, known as C41-compatible film, that allows you to process the film in the same chemicals as colour negatives. You can then also get prints made as if from colour negatives on to the colour printing paper. While these prints will not have the same tonal qualities of a 'true' black and print, they are very close, and the ability to get your black and film processed and printed in an hour, just like colour film and at the same cost, is a real boon.

● BELOW Black and white and colour 35mm films are still easy to obtain, even if the world seems to have gone digital.

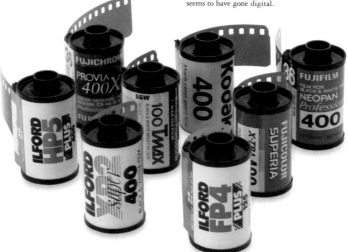

Unlike colour film, which has negative and reversal types, black and white film is almost always negative. There is no need to worry about colour balance, as black and white film can be used under any lighting conditions. It comes in speeds from very slow, such as 25 ISO, to ultra-fast at 3200 ISO – and even this can be 'push processed' to increase the speed still further. Slow film gives very fine grain and good shadow detail, and pictures can be enlarged with little loss of quality. In

contrast, the faster films are generally very grainy and the shadow detail inferior. Traditionally, when you had a black and white film processed you asked for a contact sheet. For instance, a 36-exposure roll of film was cut into six strips of six negatives. These were placed on a 10 × 8in (26 × 20cm) sheet of printing paper to make a positive print. On this contact sheet you selected and marked the negatives you wanted to have made into enlarged prints. In making this selection, you could ask

for unwanted parts of the negative to be cropped out by drawing around the area you wanted to appear on the contact sheet as a guide. Some laboratories still provide this service, but more common is for the film to be developed before the images are scanned and burned on to a CD. That way you can either make prints from the CD or copy the images on to a computer and crop and edit the photos using digital imaging software.

Specialist laboratories can provide prints in different finishes, from matt to glossy. Paper types include resin-coated, which has a plastic surface that gives faster development, needs less washing and dries faster than the traditional type. The older fibre-based paper, which gives a more subtle effect, is favoured by photographers for exhibitions and portfolios. On both these papers you can have toned prints. Sepia is the best known, but there are others.

● RIGHT Once you have first negotiated your way through the maze of photographic films, you will get to know the types you prefer to work in. Ask a stockist for advice.

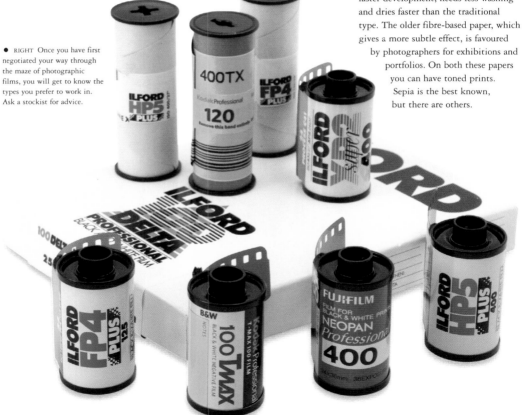

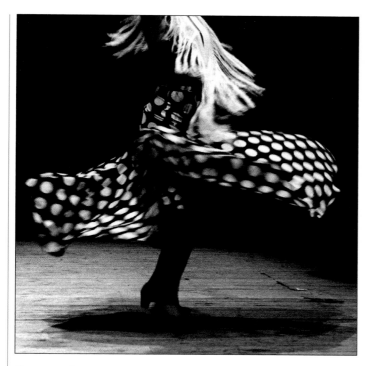

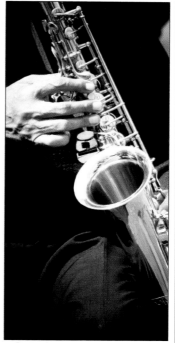

SPECIAL BLACK AND WHITE FILM

Today there are far fewer special black and white films available, although one that has endured is infrared black and white film. When used in conjunction with an infrared (IR) filter, infrared black and white film gives unusual results: pictures taken in daylight look like night scenes. This film should be tested before you use it, to avoid mistakes.

● ABOVE Stunningly simple images are possible with black and white film. Often a colourful subject such as a flamenco dancer actually works best in black and white.

FILTERS FOR BLACK AND WHITE

Although you do not need to use light balancing filters for black and white film, some coloured filters can add dramatic interest to

● ABOVE This photograph in sepia matches the smoky, classic image of a jazz saxaphone. In black and white, the image would not have been so atmospheric.

your images. For example, using a yellow filter will darken a blue sky and make the clouds stand out sharply. A red filter will exaggerate the effect: even a blue sky with white clouds will look positively stormy.

● ABOVE Film for large format film-back cameras comes in boxes of sheets, both in colour and black and white.

CARE OF NEGATIVES
AND TRANSPARENCIES

Negatives and transparencies form an archive of images, preserving memories and moments forever. Traditionalists will defend them even today when most people are storing their images on a computer hard drive. If your computer malfunctions, your images could be lost, and of course this does not apply to a drawer full of slides! Perhaps the best thing to do, if you work in film, is to store your negatives and transparencies as well as scanning your prints to keep an electronic record.

With film, as with digital photography, a visual diary of children can be built up from birth. These children may well have children of their own one day, and even grandchildren. What better way of seeing a family's

development, a history of its background, even the country it has come from, than in a series of photographs? Perhaps your photographs will become an extension of your grandparents' collection, forming a set with a long time span. If all the negatives have been kept in good condition, then future generations can assemble a fascinating visual family tree down through the ages.

It is only too easy to mislay colour negatives and transparencies. This can be a great pity; if prints are destroyed, or friends or relatives would like copies of your pictures, others can always be produced from the negatives. Note that while it is possible to reproduce an image from an existing print, the quality will not be as good.

STORAGE OF NEGATIVES

When negatives are printed at a lab, they are usually returned with prints in a wallet. If they are catalogued and dated properly, these provide a perfectly adequate storage system. The wallets can be filed in a drawer with a simple log of what they are. Alternatively, special negative storage filing systems are available. These consist of double-thickness plastic or paper sheets with pockets or channels for holding the negatives. The sheets are then stored in binders, archival boxes or hung from metal rods in filing cabinet drawers.

● BELOW Ring binders are cheap to buy and will keep your slides and transparencies neat, accessible and well protected.

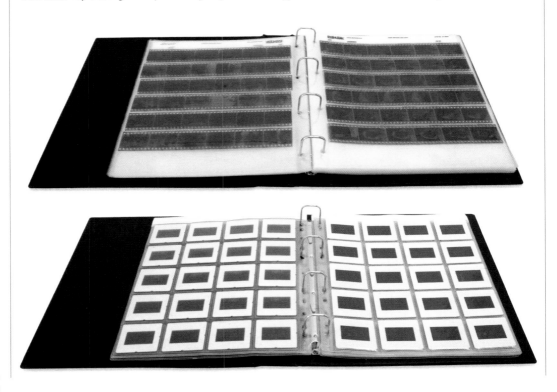

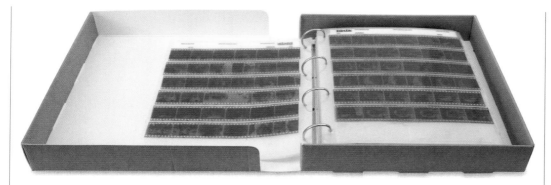

● ABOVE A box file such as this one is easy to store flat or stacked, and keeps your transparencies in mint condition, ready for you to have developed at some point in the future, if you want to.

● RIGHT A light box is handy for viewing your slides and negatives. You can purchase equipment such as this second-hand at very little cost.

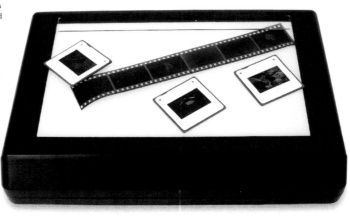

It is quick and simple, if you have a neat and simple filing system, to find the series of photographs you want, pull the sheets out and scan through the pictures by holding them against the light from a window or using a light box. You can then get any new prints made.

STORAGE OF TRANSPARENCIES

If they are mounted as slides, transparencies can be stored in the same way as negatives above, or in slide boxes, grooved to take a mounted slide, with an index for cataloguing the pictures. If the slides are for projection, they can be kept in a slide projector magazine or tray. These have dust covers and can be clearly indexed as before.

It is a good idea to edit your collection of slides and transparencies from time to time. Be ruthless. There may be some photographs that do not work and have no particular value either aesthetically or by being the only visual record of a person or a place that you have. Try to resist the temptation to keep every photograph you have ever taken, and remember that there is

● RIGHT Slides can be loaded into a viewer and projected on to a screen or clean white wall in a darkened room. This is a pleasant and simple, if rather old-fashioned, way to view your photographs or show them to a group of friends.

nothing more boring than watching a poor-quality, endless slide show of somebody else's family event or holiday. If you sit down and enjoy going through your collection, you can edit it down and discard the less interesting shots. In this way, you can keep any subsequent shows short and interesting for viewers. Of course, the great side effect of a clear out is that it will make more room for new shots in your binders and files. It is also interesting to see how your work and interests have developed over the years – often your photography has improved far more than you give yourself credit for.

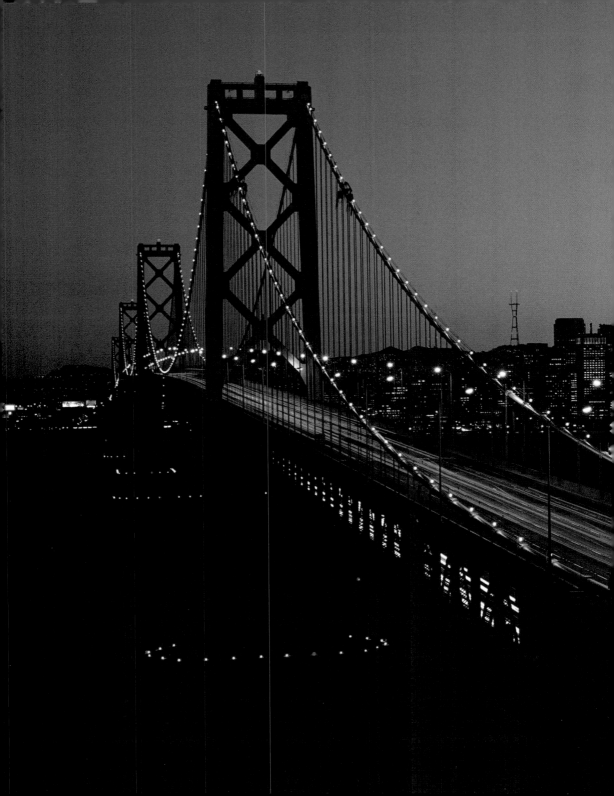

PHOTOGRAPHY

TECHNIQUES

● LEFT It is worth taking a bit of extra time to get the composition right when taking your photographs. This night photograph of the Golden Gate Bridge in San Francisco is a good example of the use of perspective to create interest. The bright streaks of light from cars crossing the bridge lead the eye into the picture.

There are different sized apertures on a camera to allow different amounts of light to pass through on to the film. When the shutter is released, it allows light to pass through the aperture. It is necessary to have a shutter as well as an aperture because the aperture controls depth of field as well as contributing to the exposure of a film.

The correlation between shutter speed and aperture size is a direct one; the immediate situation or the effect required dictates the necessary combination of shutter speed and size of aperture. If, for instance, an exposure of ⅟₁₅ second and an aperture of f22 are needed, the aperture would get wider as the shutter speed increases, e.g.

⅟₃₀ second	f16
⅟₆₀ second	f11
⅟₁₂₅ second	f8

DEPTH OF FIELD

The depth of field is the distance in front of and beyond the sharply focused subject of the picture. With a standard lens set on its widest aperture of f1.8, for example, and a subject 1.8m (2yds) from the camera, very little of the background and even less of the foreground would be in focus. However, if the lens is stopped down and the aperture is set to f16 or f22, much more of the background and foreground will be sharp.

With a wide-angle lens, depth of field will be greater even at wider apertures than it would be with a telephoto lens.

Depth of field plays an important part of the creation of a finished photograph. If, for example, the subject of the picture is a head and shoulders portrait of a person, yet with a distracting or unattractive background, it can be the depth of field that can be altered to put the background out of focus so that the person is the only clear part of the shot. If, on the other hand, the background is important or the subject is a group of people or objects at different distances from the camera where each one must appear sharp, a small aperture is needed. A small aperture would bring more of the picture into sharp focus.

APERTURE PRIORITY

Higher-end film cameras have a shooting mode called aperture priority. When the aperture is set, the camera automatically adjusts the shutter speed. Care must be taken in cases where the chosen aperture is quite small, e.g. f11 or f16, as the shutter speed selected may be too slow to take an accurate shot without the steadying aid of a tripod or other support.

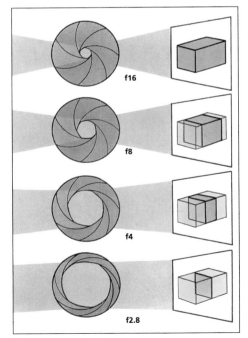

● LEFT There is a direct correlation between aperture size and depth of field. As the aperture decreases, more of the subject is in focus.

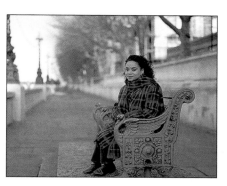

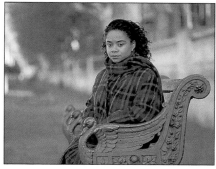

- ABOVE This picture was taken using a standard lens at an aperture of f2.8. The girl is in focus and so is the front arm of the seat, but everything else is out of focus.

- ABOVE In this picture a medium telephoto lens was used and focused on the girl. Depth of field is minimal at an aperture of f4.5.

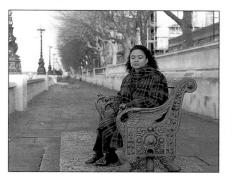

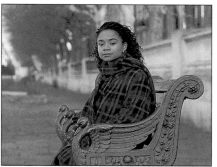

- ABOVE In this picture an aperture of f8 was used. More of the seat and background are sharper, but the distance is still unclear.

- ABOVE Using the same telephoto lens, an aperture of f11 has been used, but the background still remains very soft.

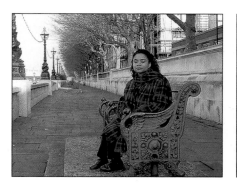

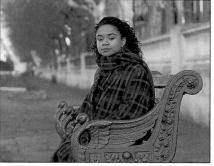

- ABOVE Here the lens was stopped down to f22, and all the seat is sharp and the far distance is only slightly soft. By reducing the size of the aperture, more of the picture is brought into focus, i.e. the depth of field increases.

- ABOVE With the lens stopped right down to f32 much more of the picture is in focus, yet it is not as sharp as in the first picture. Depth of field is greater with wide-angle lenses than it is with telephoto lenses.

● BELOW Shutters at various stages of opening. A leaf shutter (top row) and a focal plane shutter (bottom row).

The opening of the shutter of a camera determines the amount of time light is allowed to pass through the lens on to the film. As well as affecting exposure, the shutter speed can also freeze a moving object as a sharp image on film and reduce camera shake.

FAST-MOVING OBJECTS

For hand-held shots it is virtually impossible to hold the camera completely steady at shutter speeds of ⅓₀ second or less without mounting the camera on a tripod or bracing it against a solid support, such as a wall.

Imagine a car or a person passing quickly across a chosen viewpoint. If the shutter speed is set at ¹⁄₆₀ second or less, the moving object would appear blurred on the photograph. However, if the shutter speed were ¹⁄₂₅₀ second or more, the moving object would be clear, 'frozen' in action. In the case of the car, it can be difficult to tell whether it is moving or stationary; this may result in a dull picture. A better way to illustrate action is to use a slower shutter speed and 'pan' the camera, following the moving object and taking the picture when it is directly in front. This type of photography may take a little practice to perfect, but it produces striking images where the background is blurred and the moving object sharp, illustrating very effectively the speed at which it was travelling.

USING FLASH WITH SLR CAMERAS

With SLR cameras the shutter speed should be set to the manufacturers' recommended setting when using flash. This is usually ¹⁄₆₀ or ¹⁄₁₂₅ second.

● RIGHT In this picture of a fast-flowing river, the camera was mounted on a tripod and a slow shutter speed of ¼ second was used.

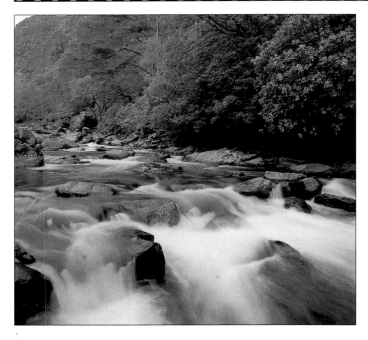

● RIGHT When a long exposure is required, in this case 20 seconds for this night shot of a building, the shutter was set to the T setting. This meant that when the shutter was fired, it remained open until it was depressed again. If the camera only has a setting on the shutter speed dial marked B, the shutter release has to remain depressed.

● BELOW When using flash with a camera that has a focal plane shutter, it is important to set the camera at the manufacturer's designated speed. This might be ⅟125 second, for instance, or there might be a flash symbol on the shutter speed dial for this. If the speed used is in excess of this setting, only part of the frame will be exposed, as shown in the first three frames.

If a faster speed is used, only part of the film will be exposed as the flash will fire before the blinds of the shutter have fully opened. With cameras that have a leaf shutter or a shutter between the lens, the flash can be synchronized to any speed. This is a great advantage in situations where flash has to be balanced with daylight.

B AND T SETTINGS

On some shutter speed dials there are two settings marked B and T. When the shutter ring is set to B, the shutter will remain open for as long as the shutter release button is depressed. If it is set to T, the shutter will remain open even when the shutter release button is released, closing when the button is depressed again. Both these settings are for use with pictures that require a long exposure.

AUTOMATIC SHUTTER SPEED SELECTION

Some cameras have a shooting mode called shutter priority. This means that when the shutter speed is adjusted manually, the camera selects the aperture automatically.

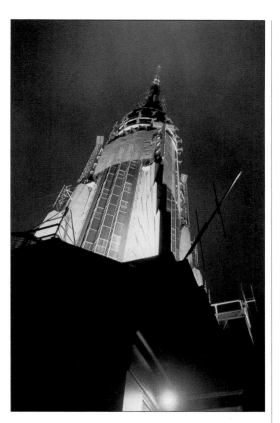

● BELOW When photographing a moving object, the faster the shutter speed, the sharper the object will appear in the photo.

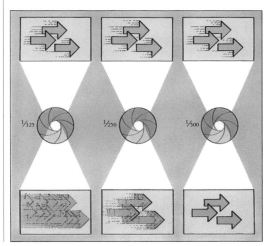

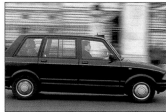

● LEFT If the camera is moved in line with a moving object and a shutter speed of ⅟60 second is used, the object will remain sharp but the background will be blurred. This technique is called panning.

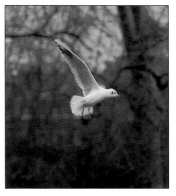

● LEFT By contrast, a shutter speed of ⅟250 second was used to photograph this bird in flight, and it has 'frozen' virtually all the movement.

Most 35mm SLR cameras have built-in exposure metering systems. These should enable the photographer to get the correct exposure every time. However, in many situations the metering system is led astray by the general level of light, so that the subject of the photograph is over- or underexposed. This is because many systems take an average reading of the illumination over the whole frame.

If you are photographing a person against a white wall, or if there is a lot of sky in the frame, these big light areas will have the greatest influence on the meter. Unless you compensate for this, the person will come out underexposed, and in extreme cases reduced to a silhouette. Conversely, if you place a person against a dark background, the metering system will read mainly for this area, and if you do not make an adjustment, the person will come out overexposed.

AUTOMATIC EXPOSURE LOCK

This problem can be resolved by using the camera's automatic exposure lock. This sets itself when the shutter release is lightly pressed. It holds the current exposure setting until the release is pressed to fire the shutter, or until the button is released altogether. So you can go up close to your subject, take an accurate reading from their flesh tones, hold down the shutter release and go back to your chosen viewpoint for the composition. If you want to take several shots, you will have to follow the same procedure for each one.

SPOT METERING

If your camera has a variable metering system, you can use spot metering in such cases. This restricts the meter to measuring the light falling on a small spot in the centre of the viewfinder.

USING A HAND-HELD METER

There are two main ways of taking a reading with a hand-held meter:
● For a reflected light reading, point the meter at the subject and take a reading of the light reflected from it.
● For an incident light reading, place a small white disc, or invercone, over the meter cell. Some meters have a white blind which can be slid over the cell. Hold the meter against the subject and point it back towards the camera. This gives a more accurate reading of the light falling on the subject.

BRACKETING

Another way of getting the correct exposure is to bracket. For example, imagine that the metering system is giving a reading of $\frac{1}{125}$ at f8. If you take one shot at this setting, one slightly over it and one slightly under, when the film is processed you can judge which exposure has worked best, and make a print from that negative.

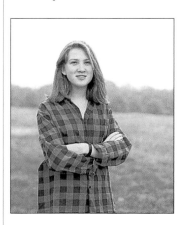

● ABOVE Bracketing exposures lets you make slight variations in exposure that may make all the difference to the final picture. In this case, the difference was $\frac{1}{3}$ of a stop between each one. In this first image, the meter gave a reading that has slightly underexposed the girl, making her eyes look heavy and dark.

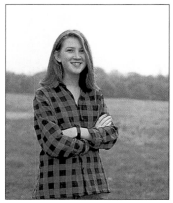

● ABOVE With the aperture increased slightly, the skin tones are more natural and the shadowiness of the eyes has been eliminated.

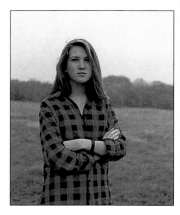

● ABOVE A further increase in the exposure has made the facial features begin to burn out. So this last picture would be chosen for the final print.

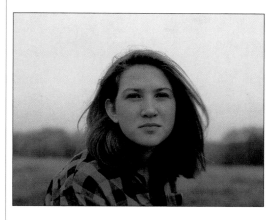

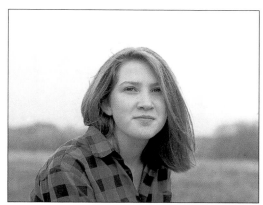

● ABOVE The camera meter took an average reading. As there was so much sky, which even on a dull day is bright in comparison to other areas of the picture, the girl has come out underexposed.

● ABOVE RIGHT Going in close and using the camera's exposure lock has given a truer reading of the flesh tones, and a far more flattering exposure.

● RIGHT Spot metering has given an accurate exposure of the girl. If your camera does not have this feature, you will have to use the exposure lock or a hand-held meter.

It is likely that any film camera you buy that was manufactured in the mid-1980s and beyond will have some form of autofocus facility built in. In some cases, the camera emits an invisible infrared beam which bounces back off the subject to the camera in much the same way that radar works. The camera analyses this information and sets the focus to the correct distance by means of a small electric motor within the lens. Other more sophisticated autofocus systems feature sensors in the camera body that detect contrast. The concept being that the more the subject is in focus the greater its contrast. The motors in the lens adjust the point of focus until the optimum contrast is detected.

Autofocus systems help you achieve focus almost instantly, but there are a few points to remember before shooting the picture. On the most simple autofocus cameras the area analysed by the autofocus mechanism will be in the centre of the frame; it will be this part that the camera focuses on even if the main subject is to one side and therefore out of the autofocus range. It is very simple to learn how to alter the focus by manually overriding this mechanism. Most autofocusing SLR cameras have a manual override for focusing, but when in autofocus mode you may need to find your point of focus and recompose the shot.

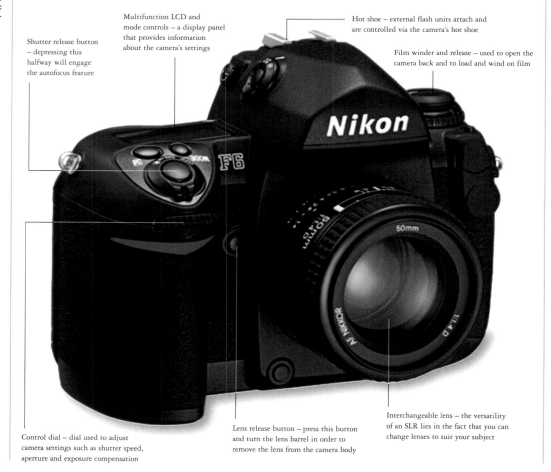

Multifunction LCD and mode controls – a display panel that provides information about the camera's settings

Shutter release button – depressing this halfway will engage the autofocus feature

Hot shoe – external flash units attach and are controlled via the camera's hot shoe

Film winder and release – used to open the camera back and to load and wind on film

Control dial – dial used to adjust camera settings such as shutter speed, aperture and exposure compensation

Lens release button – press this button and turn the lens barrel in order to remove the lens from the camera body

Interchangeable lens – the versatility of an SLR lies in the fact that you can change lenses to suit your subject

 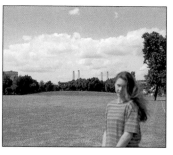 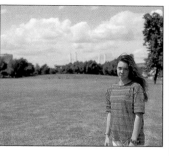

● ABOVE In this shot the person is in the centre of the frame and is perfectly sharp. The background is out of focus as the automatic focusing mechanism has 'fixed' on to the subject in the foreground. Perhaps the subject needs to be moved to one side in order to reveal or conceal part of the background.

● ABOVE By repositioning the camera so that the person is at one side of the picture, the background comes into sharp focus, but the girl is now blurred.

● ABOVE Eliminating the problem is quite simple. First point the camera at the person and gently depress the shutter release button to a halfway position. This will fix the autofocus mechanism on the subject in the foreground. Keeping the shutter release button depressed, move the camera to the desired position so that the picture is composed satisfactorily. Then depress the shutter release button fully. The picture has now been taken, and the person is in focus.

● RIGHT Autofocus is excellent for capturing instant and spontaneous shots that retain the essence of a particular moment.

ADVANTAGES OF AUTOMATIC CAMERAS

● Automatic focusing allows spontaneous pictures to be captured instantly without time-consuming dial adjustments.

● The built-in flash provides quick, on-the-spot lighting for every occasion.

● Light exposure is metered automatically, saving on adjustment and measuring time.

● 'Hands-free' pictures can be taken using the self-timer; even the photographer can appear in the shot.

● The small, compact shape makes the camera easily portable in all situations.

PHOTOGRAPHY TECHNIQUES

As cameras have becoming increasingly sophisticated with their built-in exposure metering systems, it would seem to follow that the photographer has more time to concentrate on areas such as composition. However, this is often not the case. Unwanted intrusions confuse and distract the eye; backgrounds that are irrelevant or dominating overpower the foreground, and foregrounds that should lead the eye into the picture either occupy too great an area or appear merely because of incorrect framing. All these faults can be corrected with very little effort and only minimal preparation.

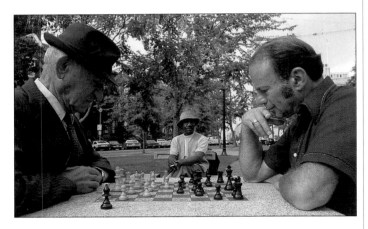

● ABOVE Even when a photographic opportunity occurs by chance, it pays to take time to consider the general composition. Here the chess board fills the centre of the foreground and the two subjects are positioned on either side, creating a perfect balance. The scene captures a particular image of society, especially with the inclusion of the third man in the background; although not deliberately arranged, the three people and the juxtaposed chess board have become key elements in the final photograph.

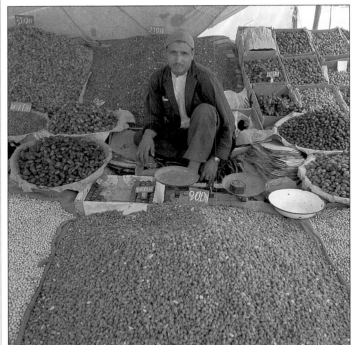

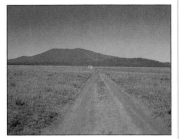

● ABOVE This very simple shot has all the ingredients of a good composition. The foreground is uncluttered, and the pathway leads from the foreground directly to the centre of interest, the house. The house is set against a backdrop of small hills, which do not overpower the house but provide a contrast and add interest by breaking up the uniform stretch of blue sky.

● ABOVE This nut-seller is the centre of interest and as such occupies the middle position in the shot. Do not be afraid of placing the subject in a prominent position within the frame of the picture. Here the subject sits among a display of his wares; this helps draw the eye towards him yet also around him as more and more items become apparent. Always retain an even balance between the subject and the surroundings.

● RIGHT The arch
in the foreground
provides a natural
frame for this scene
in a church in
Moscow. The arch
is complemented
by a series of other
arches that can
be seen in the
background as the
eye travels from one
to the other in a
smooth sequence.
There are no
unsightly intrusions
in either the
foreground or
background.
This is a strong
composition which
may well have been
weaker if taken
from a different
viewpoint.

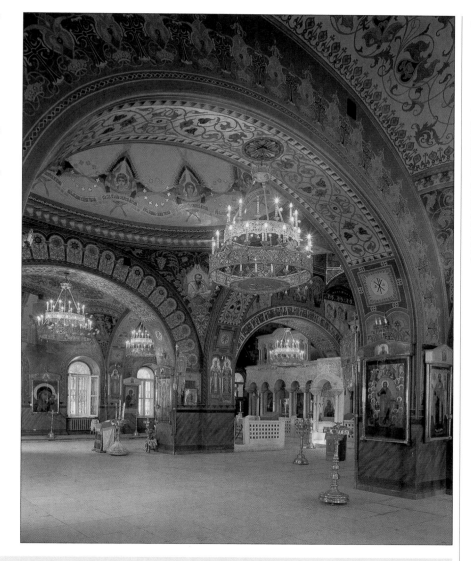

THREE KEY AREAS TO BE CONSIDERED IN COMPOSITION

1 The centre of interest – having decided what the central subject of the photograph is to be, ascertain where the photograph is to be shot from to achieve the most effective background.

2 Possible distractions or intrusions – examine carefully the subject, background and foreground to ensure the picture will not be spoilt by an unwanted object. It is only too easy to mar a beautiful building with a traffic sign in the foreground, or to produce a portrait of some friends complete with a telegraph pole emerging from the top of one of their heads. Usually an intruding object can be removed from the composition simply by moving slightly to one side. It is worth waiting for any moving vehicles to pass by.

3 Enhancing the foreground – it is important to decide if there is anything that might add to the foreground without detracting from or obscuring the centre of interest.

Foregrounds can play an important part in the general composition of photographs. A point of interest in the foreground close to the camera can be used either as a framing device or as a tool to lead the eye into the picture. This type of added interest can make all the difference between the exciting and the mediocre.

U SING F OREGROUND AS A D ISGUISE

Foregrounds can also be used to hide untidy objects or unwanted intrusions in the middle or background of the picture. However, it is important to make sure that the foreground does not dominate the picture, as then it will detract from the main subject of the photograph, becoming as much of an intrusion as the detail it is attempting to disguise.

O BJECTS IN THE F OREGROUND

Although objects in the foreground of a picture can add interest, it is all too easy to let them appear with monotonous regularity. This is a danger with a series of pictures taken from similar viewpoints, yet can be easily avoided with a little thought. Take time to evaluate what is in front of the camera; use all the components to their best advantage in the final shot.

When objects are included in the foreground, care must be taken with the exposure. Check to see if the objects are in shadow compared to the central portion of the shot and background, as this may produce an ugly dark shape with no detail visible. If the shadow is unavoidable, try correcting it using a reflector or fill-in flash.

Also check to see if the camera needs to be higher than the object in the foreground. If not, make sure the object is not filling too much of the frame.

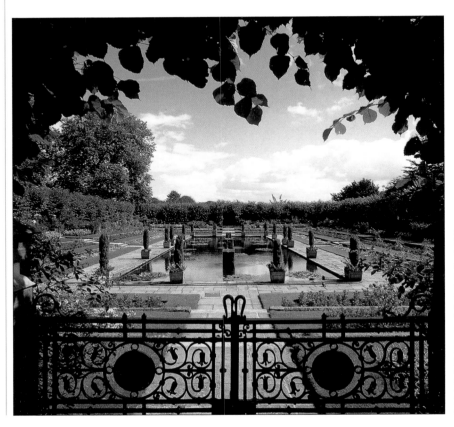

● LEFT This picture of a formal garden has been enhanced by the use of the foliage of the outer trees as a framing device. The gates at the bottom of the frame complete the foreground interest. The result gives the impression of peering into a 'secret' garden. If the camera had been positioned further forward and the foreground lost, the picture would have looked entirely different.

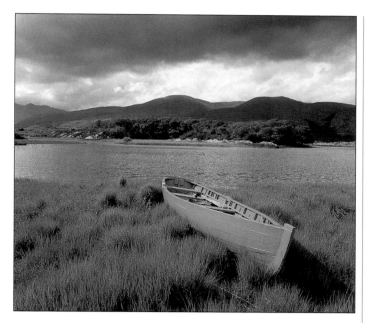

USE OF PERSPECTIVE TO CREATE FOREGROUND INTEREST

Additional foreground interest can be created by the use of perspective, for example the furrows in a ploughed field stretching out into the distance. In this case, a low viewpoint might be best. When taking a landscape shot, the sky can often be a dominating factor so that the landscape scene itself is overpowered. If this happens, perhaps the addition of a tree with overhanging branches within the shot could frame the top of the picture and diminish the impact of the sky.

● ABOVE Foreground objects do not always need to be placed dead centre. Here the boat is in the bottom right-hand corner of the frame and creates an added degree of foreground interest. The colour of the boat complements the colour of the lush green grass without providing too harsh a contrast. If a picture of this sort is to be part of a series, try to vary the position of the object in the foreground so that it does not become a dull motif, detracting from the shots themselves.

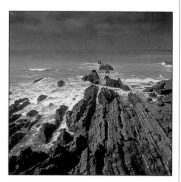

● ABOVE The strong lines of the strata shoot out from the foreground and pierce the sea, leading the eye straight into this picture and creating a powerful composition. If the photograph had been taken from a position at the end of the rocks, the foreground would have been merely a dull stretch of sea with no added interest.

● ABOVE Not all historical buildings are always at their best – as here in Reims, France, where the cathedral was covered in scaffolding. Added to this, the early-morning sun rose behind the cathedral, and since there was no time to wait for the sun's position to alter, a viewpoint was found some distance from the front of the building. A 200mm telephoto lens was used, and by having the trees in the foreground as a framing device, the untidy scaffolding was concealed and the direct sunlight was blocked.

USING BACKGROUND

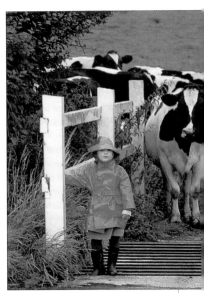

The background of a picture can enhance the overall composition of an image in ways similar to the effects of the foreground. As a general rule, backgrounds should not dominate the photograph, obscuring the main subject. This jars the eye and gives an overall impression of a cluttered photograph. Similarly, a flat, dull background can influence the whole picture so that all interest is lost. A telephoto lens can produce a compressed image, bringing the background forward and reducing the depth between the middle area and the foreground.

The weather can create dramatic effects; if dark clouds are hanging in the sky, watch out for isolated bursts of sunlight which can spotlight areas of the foreground, underexposing and making the dark areas even darker.

When taking a shot of an apparently tranquil landscape, check to see if there are any roads or tracks running through. If there are, wait until traffic has dispersed, as an unsightly track can ruin an otherwise beautiful scene.

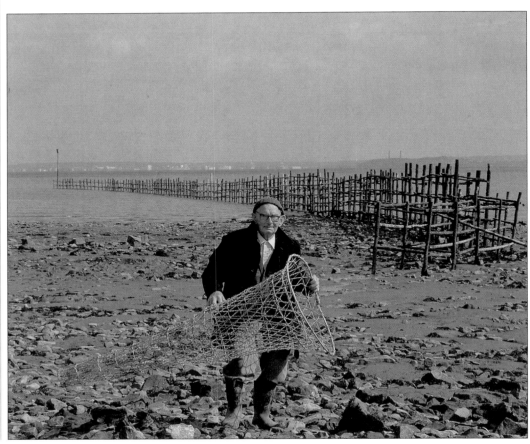

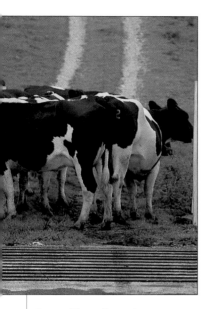

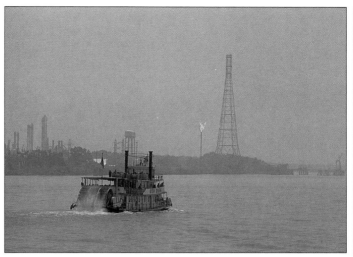

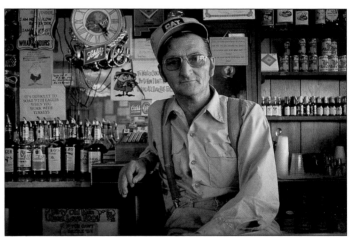

● ABOVE The cows form an almost monochromatic background to this picture. The track that comes down to the gate balances the picture and enhances the general composition, yet nothing detracts from the young girl. Her bright raincoat and hat are set off by the black and white cows, and the juxtaposition of her diminutive size alongside the cows adds a subtle touch of humour to the shot.

● ABOVE RIGHT The ever-burning flame of this oil refinery on the banks of the Mississippi at New Orleans relieves an otherwise dull background. It also provides a powerful contrast with the more traditional technology of the old paddle steamer in the foreground. It always pays to be alert to pictures where the background and foreground provide not only a visual contrast but can also make a wider abstract statement in visual terms.

● MIDDLE RIGHT This picture was taken using only the available light coming in through a small window and with an exposure of ⅛ second, bracing the camera against the bar. It is a clear example of how the background can provide information about the subject while at the same time adding extra interest and detail.

● LEFT This salmon fisherman is holding a putcher, a funnel-shaped basket used to catch salmon as they swim out to sea. The stakes stretching out behind echo the mood of the putcher, and convey a greater sense of the man and his work.

KEY POINTS TO NOTE ABOUT BACKGROUNDS

1 Is the background overpowering? Will it overshadow the subject of the picture? On the other hand, does it have enough interest to prevent it from being dull?

2 Does the background behind a human subject represent anything about the person's work or environment?

3 Are the background colours harmonious or unusual in some way? A telephoto lens can push the background out of focus, throwing up some interesting shapes and muted colours.

4 Does the sky appear in the background? If there are any clouds, try to retain their clarity and detail, perhaps by using a graduated neutral density filter or polarizing filter, or a yellow filter with black and white film.

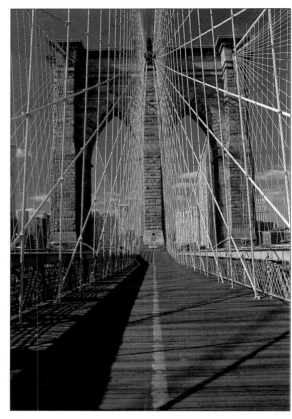

PHOTOGRAPHY TECHNIQUES

There are many situations when taking a photograph where a simple alteration of viewpoint can make all the difference. Viewpoint can be defined as the position from which a photograph is taken, and takes into account the background and foreground, and any interesting angles that will lead the eye naturally towards the emphasis of the image. By using different viewpoints, the photographer can dramatically alter the impact of a picture.

Often people will say to a professional photographer something along the lines of, 'But you've got all the equipment!' In fact, all that it takes to achieve a better view is a little thought of where one should stand and how the foreground can be utilized to the greatest effect. On many occasions it may be possible to utilize detail in the foreground by either tilting the camera downward or by moving slightly to one side. These small shifts of position or angle, that may seem insignificant at the time, can produce the difference between the dramatic and the dull.

● BELOW The choice of lens is important for the composition of a picture.

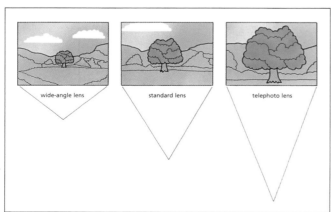

wide-angle lens

standard lens

telephoto lens

● ABOVE AND INSET Viewed individually, there may seem little to choose between these two pictures of Brooklyn Bridge. The shots were taken within 46m (150ft) of one another, and within a short space of time. The upper picture was taken from further away than the lower one; much of its impact is lost by the inclusion of too much sky at the top of the frame, and the cloud is an added distraction.

The lower picture was taken from much nearer to the bridge using a slightly lower viewpoint. This means that the verticals have converged to a greater degree than they would have done had the shot been taken from a higher position, and the tension cables fill the frame, fanning out in all directions to draw the eye into the shot. The cloud has been cropped out, which extends the symmetry of the shot; with fewer distractions, the graphic qualities of the composition are enhanced.

EASY ESTIMATING

To help judge your choice of viewpoint, simply form a rectangle between the thumbs and forefingers of both hands, and look through to judge your chosen image.

To tighten the 'frame', slide the right hand closer to the left, keeping the rectangle steady. In order to create a 'zoom' effect, extend your arms so that the background is removed and

the subject of the picture appears larger in relation to the rectangle.

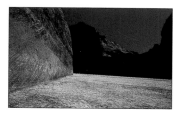

● ABOVE Standing close to one element of a photograph can add extra emphasis. The viewpoint for this picture was created by standing close to the canyon wall that appears on the left. The dramatic sweep of the wall and its horizontal strata lead the eye straight into the picture. If taken from a different position or angle, the effect would have been weaker.

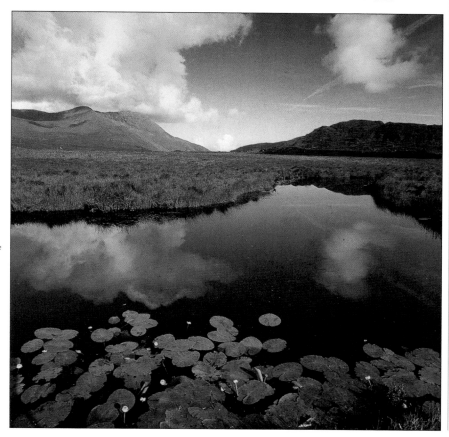

● RIGHT By tilting the camera downwards, the lilies on the water are brought into the picture. This provides extra interest in the foreground without detracting from the mountains and sky beyond. If the camera had been horizontal or tilted slightly upwards, without including the lilies, the result would have been a rather dull stretch of water and reflected cloud in the foreground.

At one time or another, all of us need a relatively powerful, if short-lived, light source that enables us to take photographs at night or indoors, using shutter speeds that are fast enough to freeze action. For this reason, many cameras have a built-in flash.

BUILT-IN FLASH

As useful as built-in flash is – and it certainly makes it possible to shoot in some situations where, without it, you may not have any usable images at all – such units do have limitations. The first drawback is the effective range, as most on-camera flashes are only capable of throwing light a distance of between 1.5m (5ft) and 3m (10ft) from the camera, which will not be powerful enough to light larger groups or scenes.

The other significant problem is 'red-eye'. This occurs because the flash unit is so close to the axis of the lens. When the flash fires, it fires directly into the subject's eyes, bounces off the retina in the back of the eye, and illuminates the eye's blood vessels.

Another problem with built-in flash is the quality of light it produces. Built-in flash will often produce stark pictures with harsh shadows. While this can be partly remedied by reducing the strength of the flash using the camera's 'flash exposure compensation' setting (if it has one), you may find that large parts of the image are underexposed.

FLASHGUNS

If you find that you are increasingly relying on the camera's built-in flash and you're not happy with the results, you may want to consider buying a flashgun. These are self-powered flash units that are fixed to the top of the camera via the camera's 'hot shoe' plate.

● ABOVE Using a flashgun attached to the side of the camera creates a harsh light with a shadow to one side.

● ABOVE By moving the flash even further to one side, the shadow is accentuated.

● ABOVE Placing a diffuser over the flash softens the shadow, but it is still quite obvious.

● ABOVE By bouncing the light off the ceiling, the shadow on the wall has been eliminated, but at the expense of a shadow under the chin.

Most of today's flashguns can be set to synchronize automatically with the camera so that the shutter opens at the same time the flash fires, as it does with the built-in flash.

The greatest benefit of using a flashgun is that it produces more light than a built-in flash. One obvious advantage of this is that more distant objects can be lit, but there's another, more significant benefit. The most useful flashguns have heads that tilt (and swivel), allowing you to 'bounce' the light off walls, ceilings or other reflective surfaces. Bounced flash produces much softer light, as in effect the light is coming from a much larger surface area, which has the effect of diffusing shadows. You need the increased power from a flashgun to make the most of this bounced flash effect. Additionally, because the light is not coming directly from the camera, but from above (or to the side), the lighting appears more natural.

● LEFT Sometimes daylight is not enough, even though a built-in meter may advise you to the contrary.

● BELOW LEFT Fill-in balanced flash helps eliminate the problem by bringing the exposure required for the person to the same level as that required for the background.

● BELOW When the flash is directly in line with the lens, a bleached-out face often results. There is always the chance of 'red-eye' as well.

● LEFT By bouncing the flash in this picture and using a fill-in flash as well, a more acceptable picture is achieved.

Often a photograph can be greatly enhanced by the use of a reflector or what is called fill-in flash. To many people it seems odd that you would use flash in bright sunlight, but it helps by reducing unattractive shadows. Suppose it is a bright day and the sun is quite high. Imagine that the people you are going to photograph are facing the sun. This will cause them to have dark shadows under their eyes and nose. Even if they turn to one side, the shadows might still remain, or if they move to a different location they may be in total shadow while the background beyond is bathed in sunshine. In either case, the use of fill-in flash will eliminate the shadows or balance the foreground with the background, creating a better shot.

To do this, take an exposure meter reading of the highlight area of the picture. Let us imagine it is $\frac{1}{125}$ second

at f11. Set the camera to this exposure. If you are using an automatic flashgun, set the aperture dial on it to f5.6, in other words two stops less than the highlight exposure. If you are using a manual flashgun, you will have to work out a combination of aperture and speed from the guide numbers of your flashgun to give you the appropriate exposure. The guide number tells you how strong a flashgun's power is and will alter depending on the speed of the film you are using. For example, a film rated at 200 ISO will give a higher guide number than a film rated at 64 ISO.

From the flashgun manufacturer's instructions you can work out the correct aperture to use. Roughly speaking, this is calculated by dividing the guide number by the flash-to-subject distance. Having done this, you are now ready to take your shot. The

important point to remember is always to underexpose the flash. If you do not do this, then the light from the flash will look too harsh and burn out all the shadow detail. Many photographers are nervous of using fill-in flash because they cannot see the effect it is having until the film is processed, unless of course they have the benefit of Polaroid.

With a reflector, on the other hand, you can see the effect immediately. You can buy custom-made reflectors in a variety of sizes and effects. These range from white and silver through to bronze and gold. Of course you might find yourself in a situation where you do not have a reflector and therefore will have to improvise. A piece of white card, a white sheet or a piece of aluminium foil will do. Let us imagine that the sun is behind your subject. If you hold the reflector so that the sun shines directly on to it, you can bounce this light back

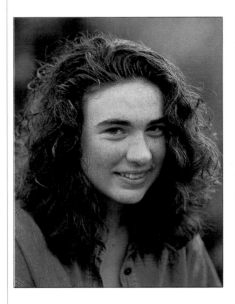

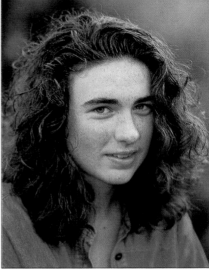

● FAR LEFT AND LEFT
The picture on the far left was taken without the addition of flash. In the second picture the aperture setting on the automatic flashgun was deliberately set at a wider opening than what was required for the available light. This resulted in a weak burst of flash that was just enough to eliminate the shadows under this young woman's eyes. If the same power had been used as for the available light, then her face would have been burnt out and the final picture would have looked most unflattering.

to your subject. By changing your position and the angle of the reflector, you can redirect the light to exactly where you need it. A silver reflector will give a harsher light than a white one, and a gold one will give a very warm effect. Many photographers prefer using a reflector to fill-in flash, as they feel it gives a more natural light.

The use of a reflector or fill-in flash is not just restricted to photographing people. Perhaps you are going to photograph a table outdoors laid for lunch. The table is in the shade but, if you expose for it, then the house in the background, for example, will be overexposed. By using the flash to illuminate the table, the two different exposures can be bought into line with one another. Whichever method you decide to use, it is of course best to practise before you take some important photographs.

● LEFT AND MIDDLE LEFT These two pictures illustrate the difference a reflector makes. In the top picture a white reflector has been used. Although this has bounced the required amount of light back into the subjects' faces, it is rather cool. In the second picture, a gold reflector makes the quality of the light warmer, giving a more pleasing effect.

● BOTTOM LEFT AND BELOW In this picture it was important to retain the detail of the house in the background. The exposure in the left picture has meant that some of the items on the table and the owner of the vineyard are in shadow. By using fill-in flash in the right picture, these shadows have been softened while still retaining detail. The result is a more pleasing balance between foreground and background.

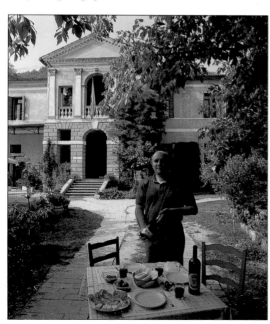

Additional lenses are the accessories that will probably do the most to improve your photography. A wide-angle lens offers you a completely different perspective on a traditional view. Not only will its wider angle of view get more into the picture, but it also has a greater depth of field than a normal or telephoto lens, so that more of the shot will be sharp.

You can have an object relatively close to the lens and still keep the background in focus. If the object is close enough, it will look much larger in proportion to the rest of the picture than it really is. With extreme wide-angle lenses, distortion can be a problem, and you should not photograph people from too close in, to avoid unflattering results. For instance, a 21mm lens pointed directly at someone's face will make the nose look enormous, the cheeks puffed out, and the ears as if they have moved around towards the back of their head. This might be fun at first, but the novelty will soon wear off and it will be time to turn to more serious applications.

● ABOVE The impact of this shot relies on the feeling of the 'big' landscape. The wide field of view gives a feeling of overwhelming space and loneliness. The lines marked on the road exaggerate the already strong perspective and give the impression that the road goes on endlessly.

● RIGHT Using a low viewpoint with a wide-angle lens makes it look as if these windmill sails are soaring into the sky. The great depth of field offered by the lens makes the whole picture sharp, even though the bottom of the sail is quite close to the lens. It is very important to choose the correct viewpoint when using a lens of this kind.

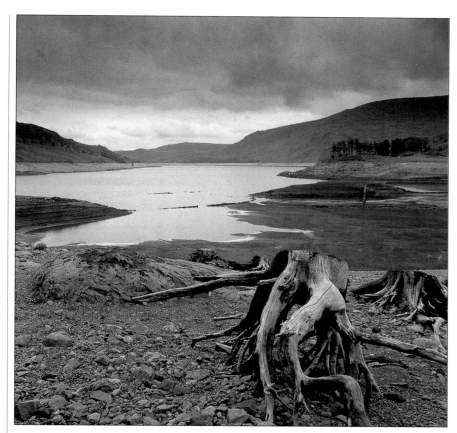

● LEFT A drought has dried up this lake, exposing an old tree stump. Again, the wide-angle lens keeps the whole picture sharp. Placing the stump at one side of the frame gives it an almost living quality, as if it is walking towards what remains of the lake.

● RIGHT When photographing people, take great care to avoid unflattering distortion. In this picture, although the hands and arms are distorted, this is within tolerable limits and does not unbalance the composition, as the viewpoint and angle of the shot have been carefully chosen. Although the arms look long and the hands, which are closest to the lens, enormous, the imbalance is acceptable because the strong hands represent the nature of the fisherman's work. His arms lead the eye straight to his face, which is framed in turn by a backdrop of his working environment. The busy background keeps the eye from dwelling too long on his hands so that, large as they are, they simply appear to be part of the composition.

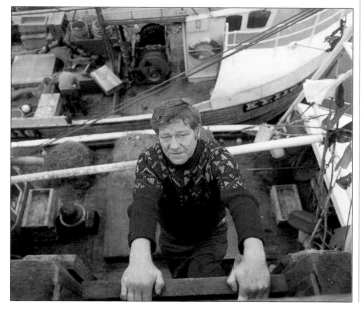

53

Telephoto lenses do much more than just bring distant objects closer. They can greatly enhance general composition. Their shallow depth of field can blur the background in a portrait to isolate and emphasize the subject. In contrast to wide-angle lenses, going in close to people has a positively flattering effect. This is because a telephoto lens slightly compresses the picture so that prominent features such as the nose and ears stay in proportion. Careful use of a telephoto lens can also help to cut out unwanted foreground clutter, allowing you to get to the heart of the picture.

EXPOSURE AND APERTURE SETTINGS

Some compensation has to be made in settings when using a telephoto lens, especially a long one. This is because the magnifying effect of the lens spreads the available light out more thinly, and the longer the lens, the greater the effect. With cameras that have TTL metering this is no problem, but a manual camera will have to be adjusted.

Telephoto lenses also tend to have smaller apertures than normal or wide-angle lenses, so that exposure must be longer. There are exceptions: some telephoto lenses have apertures as big as f2.8, but these lenses are very expensive, and few amateur photographers will consider that their usefulness justifies the price. If you need a fast long lens for a particular shot it would be more sensible to hire one.

USING A TRIPOD

The image made by a telephoto lens shifts very rapidly when the camera is moved. This fact, together with the long exposure time, may call for the use of a tripod or monopod. With a lens over 300mm this will be essential: it is almost impossible to hold the camera still enough to avoid shake and a blurred image. It is always worth paying a little extra for a good-quality, sturdy tripod or monopod.

CONVERTERS

You would need to use a very long lens such as a 500mm very often to justify its high price. If not, you might consider using a converter. This fits between the camera body and an existing lens. A 2 × converter will increase the focal length of a 250mm lens to 500mm. The price is reasonable and the image almost as sharp as that of a long lens.

● ABOVE This was shot with a 28mm wide-angle lens. It has stretched the telephone boxes apart and given a very elongated effect.

● ABOVE Here a 135 mm telephoto lens has been used. It has compressed the boxes so that they look closer together. The composition is far tighter and cuts out much unwanted detail from the frame.

● RIGHT The use of a 200mm telephoto lens has cropped a lot of clutter out of this picture. The lens has compressed the picture, reducing the apparent space between buildings. Such a composition emphasizes the contrasts between the various architectural styles, from the Victorian classical façade to the modern skyscrapers in the background.

● BELOW A 100mm telephoto lens is ideal for portraiture. Its short depth of field, especially at wide apertures, can put the background out of focus and thus allow the viewer to concentrate on the main subject. In such shots it is best to focus on the eyes, and expose for the skin tones.

PERSPECTIVE

In photography, perspective means creating a feeling of depth. There are several ways to get this effect and all of them are quite simple. It is strange, then, that so many photographs lack this element which can make all the difference to a shot.

In landscape photography, the easiest way of gaining a sense of perspective is to use a foreground. Often you can add a tree at one side of the frame, or with its foliage filling the top of the picture.

This simple addition creates an illusion, the impression that there is space between the viewpoint, the foreground and the background. Compare this to a picture with no foreground features – it will look flat and dull.

Strong, naturally formed lines can create a powerful sense of 'linear' perspective. Try standing at the end of a recently ploughed field. Look at the lines of the furrows running away from you. They will converge towards a

central point in the distance – what in the formal study of perspective is called a vanishing point. Taken from a low viewpoint, these lines will create a strong feeling of depth.

When photographing buildings, it is not difficult to exaggerate perspective. A shot of the front of a building taken straight on may lack impact, whereas a more dramatic effect may be achieved by moving in close and looking up so that the verticals converge.

● ABOVE In this picture of Wells Cathedral, the viewpoint was directly to the front. Although it shows all the façade, it lacks depth. There is no sense of perspective at all.

● ABOVE Here the viewpoint is much closer. The camera is tilted upwards and the two towers converge towards the top centre of the frame. This creates a much more powerful image.

● ABOVE The viewpoint is nearer still, and the verticals converge even more sharply. This slight change of viewpoint and camera angle greatly increases the perspective effect.

● ABOVE Another example of linear perspective: the bicycles create a seemingly endless line converging at an infinite distance. Lines of objects of any kind are one of the most effective ways of conveying perspective.

● RIGHT These red buses snaking down London's Oxford Street give a good sense of linear perspective. The uniformity of their colour adds to the feeling of depth.

● LEFT Placing this bale in the foreground and going quite close to it with a 21mm wide-angle lens creates a feeling of separation between it and the other bales, and the farm buildings beyond. This is a simple technique for adding perspective to your photographs.

SHOOTING AGAINST THE LIGHT

Many people think that you can only take good photographs if the sun is directly behind or to one side of the camera. Admittedly, by taking shots straight into the sun, flare and incorrect exposure may result, but if handled carefully these can be avoided or used to dramatic effect. To eliminate flare, a good lens hood should suffice. In fact, you should always have a lens hood attached to your camera whichever way you are shooting. Flare can result from light indirectly reflecting off a shiny surface such as a car or window, as well as directly from the sun.

Calculating exposure needs careful consideration as, if your subject is strongly backlit, it could appear as a silhouette. Although this may be the effect you are after, an adjustment to exposure will be necessary if you want your subject to be visible. If you are using a camera with built-in metering that has a choice of exposure modes such as average, centre-weighted or spot metering, then the spot metering mode will give a more accurate reading. If your camera only has metering in the average exposure mode, the chances are that it will underexpose your subject.

It is possible to overcome this if you can move in close so that the viewfinder is covering only the subject and take your meter reading at this distance. This means depressing the shutter release button about halfway. If your camera has an autoexposure lock, you now keep the shutter release button

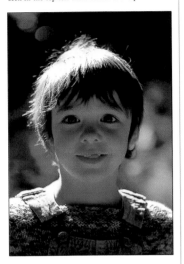

● BELOW In this picture the sun is at about 45 degrees behind the young girl. A reflector was used to bounce back a small amount of light into her face. Without this she would have been almost silhouetted against the background. Although a lens hood was used, flare can still be seen in the top left-hand corner of the picture.

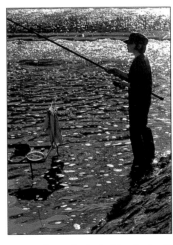

● ABOVE By exposing for the light reflecting off the water behind this boy fishing, he is shown almost in silhouette. In this case it works well because it is still obvious what activity he is involved in, and the quality of the sparkling light bouncing off the water adds a romantic feel.

● LEFT A combination of a long lens and small aperture have resulted in isolating this plant from its surroundings. The back light has helped to emphasize this effect, and the eye is drawn immediately to its delicate blooms.

● LEFT Often there is no time to use fill-in flash or a reflector to throw light back on to a subject, and this is often the case with animals. By exposing for the shadows, enough detail has been retained to record this cat's peaceful posture in the shade.

slightly depressed and return to your original viewpoint. Without taking your finger off the button, take your shot. Your subject will now be correctly exposed, although the background will be overexposed. If you are taking more than one shot from this viewpoint, you will have to repeat the procedure with each shot.

Another way around this problem is to use the exposure compensation dial – if applicable – on your camera. Set the dial to give two stops more exposure than the reading on the camera meter. If you can operate your camera manually and you have a separate exposure meter, then, as above, you could move in close to your subject to take a reading.

If you do use this method with your camera or a hand-held meter, care must be taken not to cast a shadow on your subject, otherwise an incorrect reading will be obtained and overexposure will result. The preferred method of taking a reading with a hand-held meter is to use the incident light method. This means attaching an invercone – a white disc – to the exposure meter sensor. The meter is then pointed to the camera and a reading taken. This method records the amount of light falling on your subject, as opposed to reflecting from it.

One word of warning when taking photographs into the light: the sun is very powerful and can be greatly magnified by camera lenses, so if these are pointed to the sun, damage to your eyes could result – be careful!

● BELOW By shooting straight into the sun, a very dramatic backlit picture has been obtained. A lens hood is essential in a case like this to eliminate flare. When shooting into the sun, be careful that you do not point the camera directly towards it, to avoid damage to your eyes.

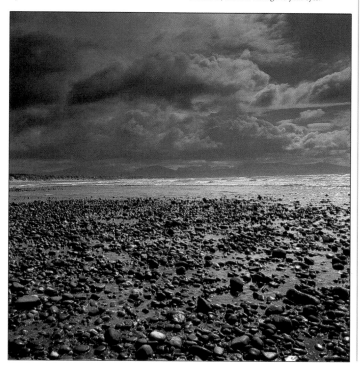

Low light, whether due to the time of day or prevailing weather conditions, does not mean that good photographs cannot be taken. It is sometimes even possible to obtain more dramatic shots in low light than in brilliant sunshine. If the weather is misty or foggy, moody pictures can be taken. If the sun is low, at the beginning or end of the day, for instance, the colour of the light will be much warmer, and can be used to dramatic advantage, emphasizing the sky and clouds. Even indoors, light filtering through a window is often perfectly adequate to light a subject without using flash.

A tripod is an asset in many low light conditions where slow shutter speeds are necessary. An alternative is to use a fast film, although the results will be grainier. Graininess can be used to creative effect, but often it will detract from the final image if not used carefully. Instead of using fast film, ordinary film can be uprated. If the film in the camera is 100 ISO, for instance, the speed dial on the camera can be altered to 200 or 400 ISO. Remember, though, to tell the laboratory this when the film is sent in for processing so that it can be developed accordingly. The disadvantage of this method is that the whole film has to be rated at the same ISO, and any increase in development will result in loss of shadow detail, increase in contrast and a grainier texture.

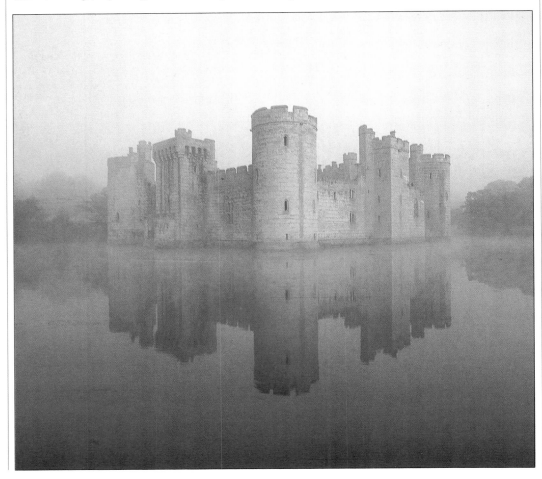

● ABOVE This shot was taken using only available light coming in from a window. The shutter speed required was $\frac{1}{15}$ second; this was too slow to allow the camera to be held by hand so a column in the restaurant was used as a support. It is virtually impossible to hold a camera steady at $\frac{1}{30}$ second or less without suffering camera shake; with a little ingenuity it is usually possible to find something to support the camera.

● RIGHT Here the setting sun has painted the sky completely red, and the clouds lend it extra depth. No tripod was available here so the camera was braced on the defensive wall of the river.

● BELOW The late evening light bathes this building in a wonderful reddish glow. The anonymous figure at the window lends an air of mystery to the overall composition. Always be on the look-out for the unexpected, especially when the light is low and hopes of a good shot are fading.

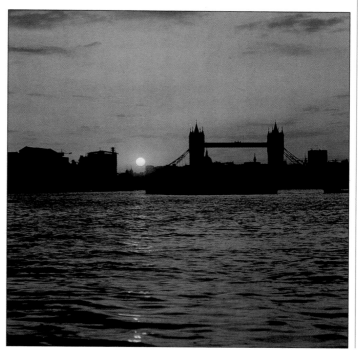

● LEFT Even adverse weather conditions can be used to the photographer's advantage. This picture of Bodiam Castle in Great Britain was taken early on a misty morning. The mist rose and fell, sometimes completely obscuring the castle. By waiting for the right moment, it was possible to take a shot in which the light had an ethereal quality. The mirror image reflected in the still waters of the moat adds to the general composition.

PHOTOGRAPHY TECHNIQUES

Any accessory used while taking a photograph can enhance the final image, however care must always be taken to ensure the images produced are effective. One of the least expensive and yet most important of accessories is a filter. Certain filters improve the colour saturation of the film or enhance the sky or quality of water. Before deciding on any filter, indeed any accessory, test it in similar situations before using it for a specific shot.

COLOUR CORRECTION FILTERS

Some manufacturers' film may have a natural bias towards results that are too blue or green, giving an unwanted coldness to the photographs. On the other hand, the film may be too warm and the results will then tend towards red or yellow. To correct these tendencies, there is a huge range of CC (colour correction) filters; for most photographers one or two colour balancing filters will prove more than adequate.

POLARIZING FILTERS

A polarizing filter is a useful accessory; not only will it enhance the quality of the blueness of a sky, making any clouds stand out with greater clarity, it can also be used to cut out unwanted reflections, such as those in shop windows or on shiny tabletops.

EXPOSURE COMPENSATION

Since many filters cut down the amount of light passing through the lens, compensation in exposure must be made. With cameras that have TTL meters this will be done automatically, but for manually operated cameras this must be taken into account before the final exposure is made. This is quite easy, as each filter comes with a number known as a filter factor which indicates the amount of compensation required for each exposure. For instance, a filter factor of 1 requires one stop increase in exposure.

● ABOVE In this picture no filter was used. Although the image is correctly exposed it has a slightly blue cast, which makes it look rather cold. The sky lacks definition and appears flat.

● ABOVE By adding an 81A filter, the blue cast has been reduced, the picture appears warmer and the contrast between the different tones is increased.

● RIGHT Here a polarizing filter has been used. This has made the blue sky darker and the wispy white clouds stand out with great clarity. If this filter is used with an SLR camera, the effect can be seen in the viewfinder as the filter is rotated.

● ABOVE In this picture an 81EF filter was used to eradicate the blueness of the overall picture. The grass and tree are well defined and the clouds and sky have body.

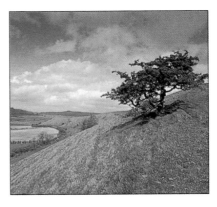

● LEFT As well as using an 81EF filter, a neutral density graduated filter has been added. This filter allows two differing areas of brightness to be brought into line with one another. In this case the hill and background required an exposure of $\frac{1}{125}$ second at f8, but the sky only needed an exposure of $\frac{1}{125}$ at f11. The graduated filter brings both areas into line so that the sky is well defined, yet the land area is not underexposed.

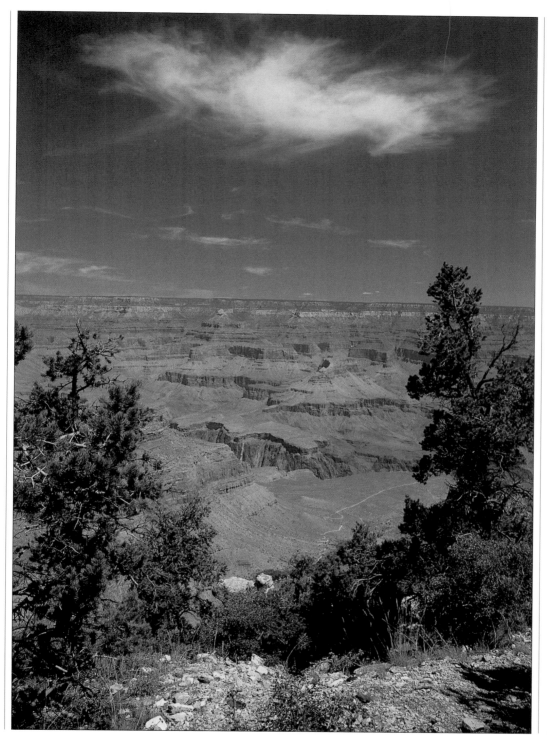

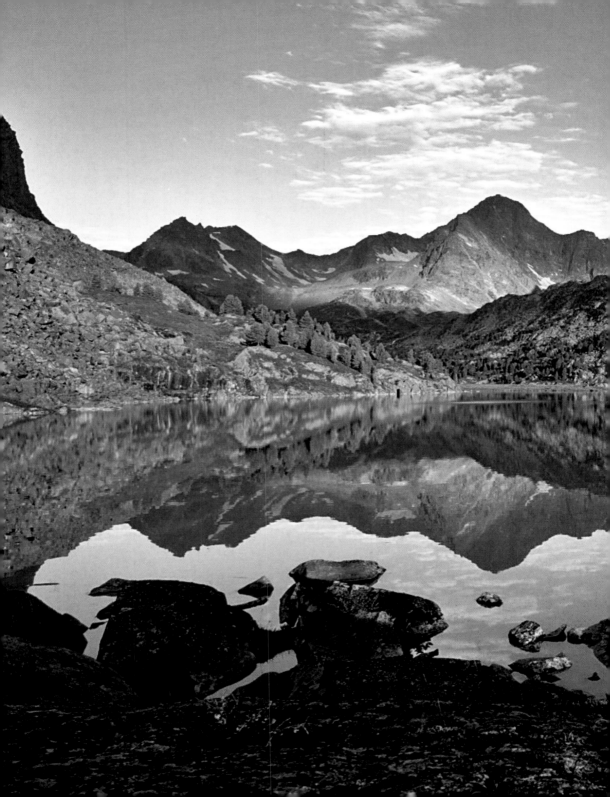

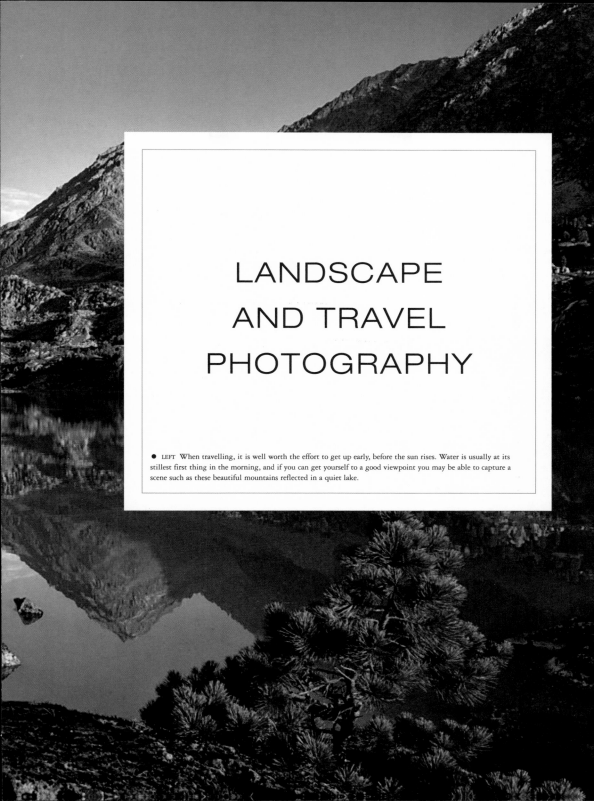

LANDSCAPE
AND TRAVEL
PHOTOGRAPHY

● LEFT When travelling, it is well worth the effort to get up early, before the sun rises. Water is usually at its stillest first thing in the morning, and if you can get yourself to a good viewpoint you may be able to capture a scene such as these beautiful mountains reflected in a quiet lake.

GENERAL COMPOSITION

The main subject matter of photographs taken while travelling will probably be landscapes. In landscape photography it is very important to take care with composition to avoid producing dull shots, for example of a lot of sky with only a thin strip of land. A commonplace image can be transformed very simply by paying attention to shadow, colour and detail, all of which are paramount in producing good landscape shots.

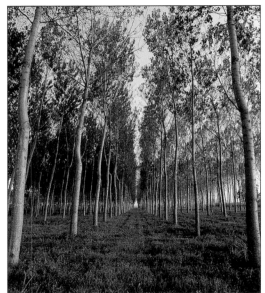

● LEFT This grouping of trees is common around the River Po in northern Italy. The planting arrangement is exaggerated by going in close using a wide-angle lens so that the long lines between the rows form a focal point for the composition. The evening light helps to create a pleasant atmosphere.

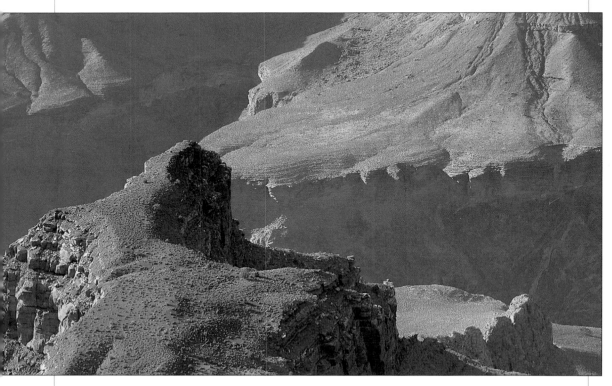

● ABOVE Give some thought to which lens to use when composing a landscape shot: it is one of the most important factors in a successful composition. By using a 200mm telephoto lens, this picture has been framed without any sky. The eye is drawn to the slightly pink terrain of the foreground while the grey rock of the canyon forms the background. The long lens has compressed the shot, further emphasizing the foreground. The trees in the foreground look like tiny bushes, and this gives an indication of the scale of the canyon.

● LEFT AND BELOW Although these two shots were taken very close to each other, one is a far better composition than the other. In the picture below, the road and tree balance one another, drawing the eye to the centre. The tree is a bold, dominant feature; the way the narrow road converges adds a sense of curiosity – what lies beyond? In the picture on the left, the tree appears to lose its dominance and the expanse of fields on either side diminishes the power of the converging sides of the road. It is clear that the smallest adjustment can make a considerable difference to the overall composition.

VARYING A LANDSCAPE SHOT

● Rotate the camera slightly to one side; this may cut out any elements of unwanted scenery or alternatively bring in an added point of interest.

● Move the camera from a horizontal (landscape) to a vertical (portrait) position; sometimes the smallest of movements – not even involving moving your feet – can have a dramatic effect.

● Try isolating a portion of the landscape against a backdrop from a different part of the image; this can emphasize scale or make a coloured field, for example, stand out from surrounding pastures.

● Notice the position of any trees; a single isolated tree or a group of trees apart from a wood or forest can be used as a device for leading the eye into the scene. Tractor furrows or a meandering stream or river have a similar effect.

● An object in one corner of the picture adds to the composition; be careful that there is enough variety in a sequence of shots – do not always place an object in the same corner, otherwise the series begins to look dull.

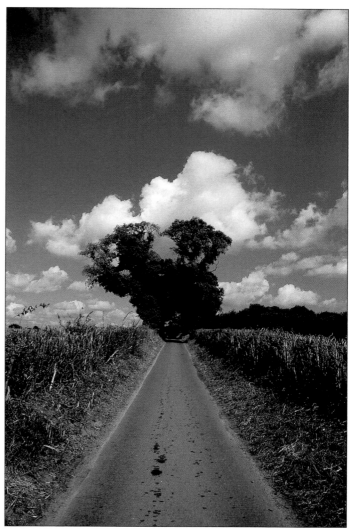

LANDSCAPE AND TRAVEL PHOTOGRAPHY

Often the view that looks most spectacular to your eyes does not come out nearly so well on film. This is not necessarily because of any technical fault: it may be just that the wrong viewpoint was chosen when pressing the shutter. All the time you look at anything, your eyes are editing the scene and suppressing uninteresting details. In contrast, the camera records just what is in front of it, and unless you have taken care to exclude things you do not want, they will appear on the print.

In many cases the picture could be improved beyond recognition by moving a short distance. The basic viewpoint may be fine, but perhaps a higher or lower viewpoint is needed; try standing on a step, or crouching down. It is worth taking the time to explore a variety of viewpoints. Even when you have taken your shot and are walking away, you may suddenly see a better

shot. If you do, take it. After all, film is the least expensive component in photography. You may never return to that place, or the light may never be the same again – so do not worry about using up another couple of frames.

PARALLAX ERROR
One common reason for not getting the picture wanted is parallax error. A camera with a separate viewfinder for the lens – that is, most cameras except single lens reflex cameras – gives a slight difference in framing between what you see and the picture you take. This makes no noticeable difference when photographing a distant object or a landscape, but the closer you go in, the greater the error. If the landscape shot has a foreground, you will certainly have to allow for parallax. If you do not, a detail you expect to be in your photograph may simply not appear, and vice versa.

● BELOW LEFT AND BELOW From looking at the background of the buildings and cliffs it is clear that both these pictures were taken from almost the same place. But the foregrounds are quite different. This shows the effect that altering the viewpoint slightly can have on the finished picture. Although both compositions work well, the one on the left is taken from a better viewpoint in relation to the sun.

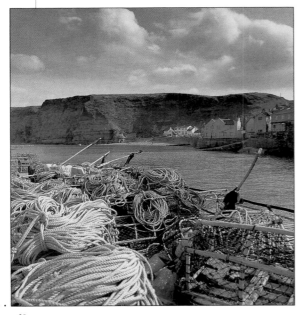
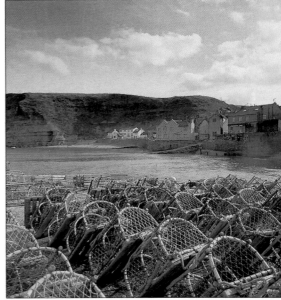

● RIGHT A central viewpoint from a bridge over both the railway track and the canal has created an interesting composition. A fairly slow shutter speed of $^1/_{60}$ of a second was used. This has made the express train slightly blurred. But instead of being a fault, it adds an air of movement and speed. In contrast, the canal looks calm and tranquil, a bygone and slower mode of transport. The viewpoint contributes greatly to the juxtaposition.

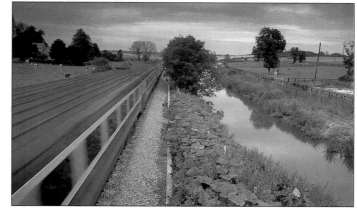

● BELOW Taking this shot from a viewpoint some way up the bank of the lake has brought the pavilion on the far side into clear view. A view from near the water's edge would have made the bridge in the middle distance cut into the pavilion, spoiling the composition.

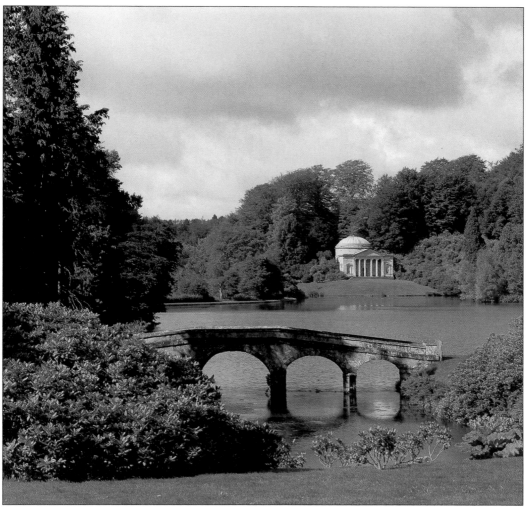

THE WEATHER

There is no such thing as perfect weather for photography. Of course, photographing people on a beach holiday in the pouring rain may present a few difficulties, but many inclement weather situations are in fact the basis for original and dramatic photographs. Overcast skies can be used to advantage and reveal more about the immediate environment than if the sun were shining on a clear day. Rain can be evocative, portraying isolation and stormy conditions. Wintry, and especially snow-covered views provide good, clear images; these are best shot in sunshine to obtain the best view of the shadows cast on crisp snow – an effect which is lost if the sky is heavy.

Predicting where light will fall is important; try to look at a map to gauge where the sun will shine strongly, and rise and set. Make sure the camera is in position at the right time to get the full effect of the quality of light required, particularly if unusual weather conditions produce dramatic cloud formations.

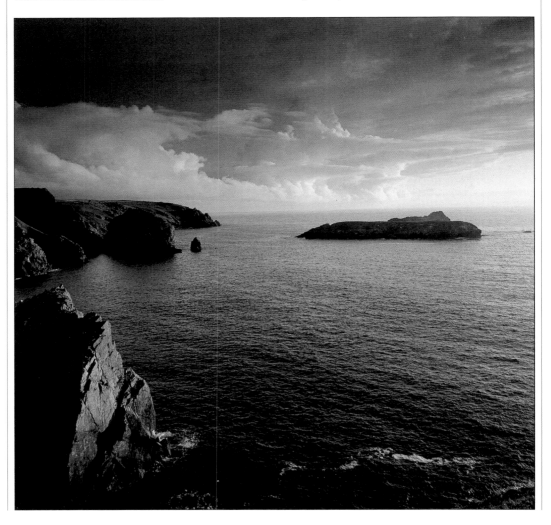

CAMERA CARE IN
EXTREME CONDITIONS

If the weather is very cold, the
shutter on the camera may freeze
and valuable picture opportunities
may be lost. Extreme heat can
ruin film, so keep it wrapped in
aluminium foil as this will keep it
a little cooler. As big a lens hood
as possible may help to shield the
lens from the rain – but beware
of cutting off the corners or
'vignetting' the picture. Do not
let weather conditions prevent
photography – be prepared to have
a go: the results could be surprising!

● LEFT Mist and
fog should not
be a deterrent to
photographers. This
almost monochromatic
picture has a strange,
eerie quality to it.
Is the boat perhaps
drifting and
abandoned? Hazy air
can add an enigmatic
quality to shots.

● ABOVE AND RIGHT Snow creates wonderful
picture possibilities. Take care not to
underexpose: there is so much reflected light
that exposure meters may read the conditions as
being much brighter than they are. Try waiting
for different light on snow scenes. Here the
picture on the right with the sun shining
brightly certainly enhances the overall effect.

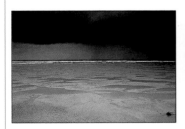

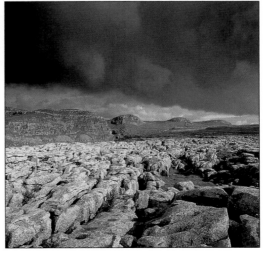

● ABOVE Even in the rain, dramatic pictures can
be taken. This storm over the Atlantic illustrates
the qualities of cold and isolation. A slow shutter
speed can help to emphasize the driving rain.

● LEFT Prior calculation of where the sun is going
to set means that full advantage can be taken of
warm evening light, as shown here where the sun
is falling on the shapes of the clouds. The same
shot taken earlier in the day would have lacked
such intensity, warmth and atmosphere.

● LEFT The heavy rain
cloud hanging over the
limestone pavement
perfectly illustrates
the visual effect that
overcast weather can
produce. Here it is
particularly apt as the
cloud hangs over rock
which has been eroded
by rainfall over the
centuries, so the image
has a double purpose –
it is visually pleasing
as well as instructive.

Throughout the day the sun constantly changes position. In photographic terms, this movement is more than one from east to west: any change in the sun will produce a different effect on any landscape. In the early morning and evening the sun will be quite low; the shadows it casts will be long and dramatic. In winter the sun will be lower still and these shadows will be even more exaggerated. At midday the sun will be high and the shadows cast will be shorter. In some cases this can lead to flat and featureless shots, so care must be taken at this time of day.

The other factor to consider is that the light cast by the sun in the early morning and late afternoon will have a warmer tone than that of midday light, so pictures taken at these times will appear redder or more orange than those taken in the middle of the day. It is well worth making the effort to get up early, before the sun rises, to be in position to capture the quality of light as dawn breaks. A little research beforehand will show where the sun will be and what it will fall on, depending on the time of year. Early and late rays of sunlight can illuminate an isolated area of a landscape in much the same way as a giant spotlight trained on the scene.

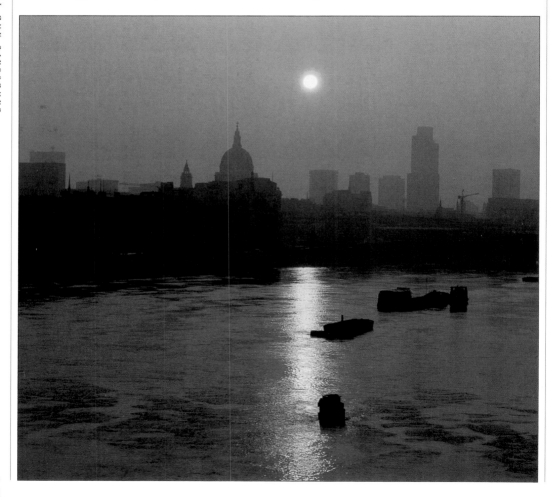

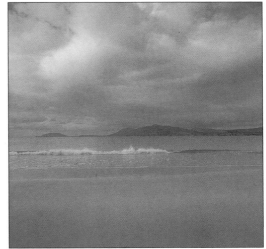

● ABOVE This shot was taken at mid-morning, yet there is enough of an angle in the light from the sun to create shadow detail. The well-defined clouds have broken up what could have been a bland sky, so that the general result has equal focus and visual impact in all areas.

● ABOVE RIGHT The early evening sun was very low on the horizon when this picture was taken. It has just started to tinge the clouds with red and darken the golden sand. By using a wide aperture, a fast enough shutter speed could be used to capture the gently breaking waves.

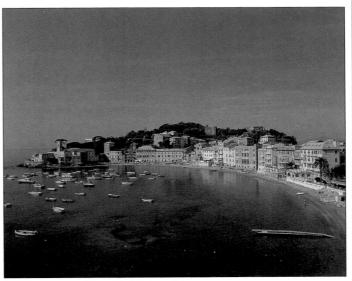

● RIGHT AND BELOW RIGHT These two pictures were taken from the same viewpoint, the one below after the sun had set. The sky is bathed in a dramatic red-orange light. In contrast, the shot taken in the morning, on the right, had the sun behind the camera, and the quality of light is much cooler. A polarizing filter was used to enhance the colour of the sea.

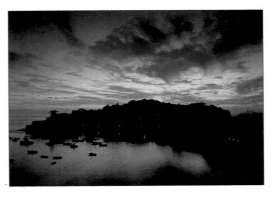

● LEFT This picture was taken just after the sun has risen, and the quality of light is very warm, casting a golden reflection on the River Thames in London. The early morning mist has diffused the sun and gently bathed the scene with a sense of calm. A little prior research meant that the picture was taken at exactly the time the sun appeared between the dome of St Paul's Cathedral and the National Westminster Bank Tower. If the shot had been taken two months earlier, the sun would have appeared to the right of the tower; four months later it would have been to the left of the cathedral dome.

Landscape photography is often enhanced by the inclusion of a human figure. The technique of combining people with landscapes can be used to illustrate a particular activity in a certain area, or to show the type of landscape a person may work or live in.

Human figures add scale to a particular feature of a landscape, such as a large rock or the height of a tree. Showing a person isolated within a landscape is an effective way of showing the desolate or lonely aspect of a region. On overcast days, a person can help to enliven an otherwise dull situation. If the person is working, try to let them continue with the task already started. Reassure the subject that he or she is a welcome part of the shot – many people assume that they are in the way and try to move out of the picture.

On a walking holiday, for instance, it might be better if your companions were seen coming through a gate or along a path while the camera is positioned on higher ground than the people to be included; but also remember not to let your shadow creep into the picture. In the early morning or late afternoon, shadows will be well defined and long. If people are to feature in the foreground of a picture, make sure that they do not block out an important point of interest in the middle or background. On the other hand, if there is something unsightly in the background, the inclusion of a person can help conceal the object.

● RIGHT The shepherd in the foreground helps to create a sense of space between himself and his village. He also diverts the eye away from the overcast weather. Local people are often very pleased to be in photographs; do not be afraid to ask them to pose.

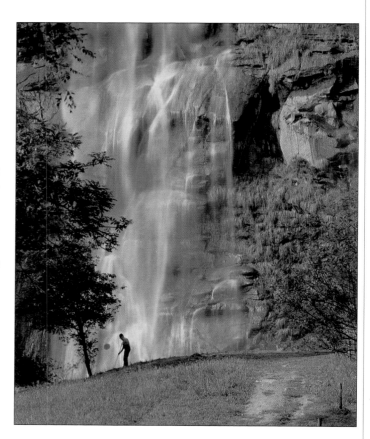

● ABOVE The man has been included in this picture to give a sense of scale; without him it would be almost impossible to tell accurately how high the waterfall is. Consider the picture without the man: as well as losing the sense of scale, the composition would be entirely different without the added point of interest, which makes an intriguing juxtaposition to the waterfall.

● LEFT This shot was taken in the early morning light. The warm tones of the sun highlight every feature of the man's face, while the cliffs behind provide both an interesting backdrop and a sense of location. This type of light would be too harsh for some people, and it may be better to wait for the position of the sun to move or to move the person into a shaded area.

● BELOW This shot was taken in winter; the people standing by the seashore add a clear sense of the desolation of the beach at this time of year, yet in contrast the setting sun bathes the sky and surrounding landscape with a warm glow.

Often a black and white photograph of a landscape or seascape can be far more evocative and dramatic than one taken in colour.

One important thing to remember is that some detail, for instance in a cloudy sky, can become flat and grey if a filter is not used. To make white puffy clouds stand out against the sky, use a yellow filter. For even greater drama, use a red one, which will turn the sky very dark.

Provided there is detail on the negative, the sky can be 'burnt in' at printing stage. This means giving certain areas of a print more exposure ('printing them up') or less exposure ('holding them back') than the rest of the picture by partly masking the print under the darkroom enlarger.

Another advantage of black and white for print making is that there is a variety of paper grades to choose from. A print made on grade 1 paper will be soft, and one made on grade 3 much harder. The whole feel of a picture can be altered by the choice of paper alone.

● ABOVE This picture shows a good tonal range. The camera was fitted with a wide-angle lens and pointed downwards to emphasize the texture of the rock in the foreground. A neutral density graduated filter was used to retain detail in the sky, and this was further emphasized when the print was made.

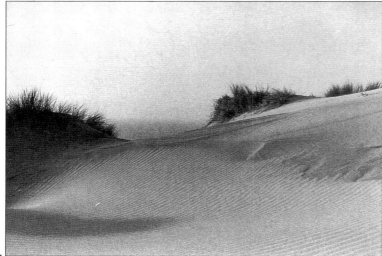

● LEFT This high-key picture of sand dunes has an almost tactile quality. Keeping the tones to the lighter end of the range has enhanced the softness of the windswept sand and given the picture a feeling of peace. When working in conditions like these, be careful that sand does not get into equipment.

In colour photography there is contrast between different colours as well as different tones. The essence of a good black and white picture is its tonal range. This does not mean that there have to be extremes of white at one end

● ABOVE Keeping the rooftops in the foreground
has increased the feeling of depth in this picture.
A medium telephoto lens, 150mm, was used,
and this has very slightly compressed the picture,
bringing the town on the other side of the
river closer in.

and black at the other. That would be
a high contrast print, and it might
be interesting; but it is the subtlety
of gradations of tone that make a rich
print. Fine-grained film, 100 ISO or
less, will give better shadow detail than
faster film, and will allow far bigger
enlargements to be made.

To see how good a black and white
landscape can be, study the work of
the late American photographer Ansel
Adams, whose studies are epitomized
by their starkly contrasting tones.

● LEFT Filters can
make a dramatic
difference to black and
white photographs, as
this shot shows. A red
filter has turned the
sky very dark. For a
less extreme effect,
a yellow filter will
help to retain detail
of white clouds.

Special care must be taken when photographing seascapes, as misleading exposure meter readings can occur. In an environment with so many reflective surfaces, the meter can be fooled into measuring the scene as brighter than it is. This can lead to underexposure and disappointing results. To overcome this problem, take a meter reading close up of some mid-tone detail.

If the camera is one with built-in autoexposure but no manual override, first decide on the composition. Then point the camera to an area of mid-tone detail, such as grey rock. Depress the shutter release button halfway; this will activate the meter and the camera will record the reading. Keeping the shutter depressed in this position, move the camera back to the scene of the original composition. Now gently depress the shutter release button fully and take the picture. To take a similar picture from a slightly different viewpoint, you will have to repeat the process for each shot.

Some cameras with a built-in autoexposure meter have a special mark on the shutter ring labelled AEL, or autoexposure lock, for taking readings like this. Its action is similar to semi-depressing the shutter release button.

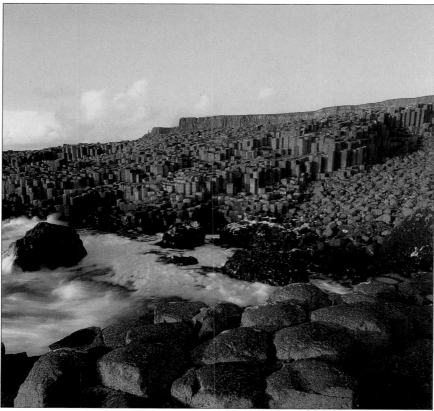

● LEFT Movement in the sea at the Giants' Causeway in Northern Ireland is captured and emphasized by a slow shutter speed, to make it look as if the sea is really pounding at the unusual hexagonal rocks that are a famous landmark in this area. The rocks are lit by warm light as sunset approaches, and the strong shadows bring out these strange forms.

LANDSCAPE AND TRAVEL PHOTOGRAPHY

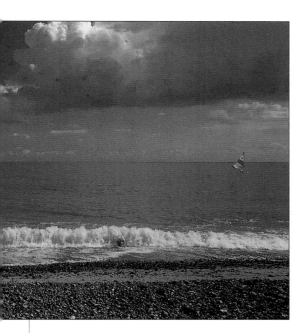

● BELOW This picture was taken as a hurricane approached; in high winds it is important to hold the camera steady, perhaps bracing it on a firm surface such as a rock or low wall if you do not have a tripod. Even at relatively fast shutter speeds, such as $\frac{1}{125}$ second, camera shake will lead to blurred pictures.

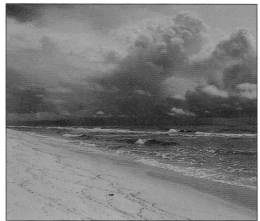

● ABOVE Always look for points of interest when shooting a seascape. This unusual high tide marker creates a focal point in the foreground, while the bright colours of the windsurfer's sail help to create a balance in the overall composition without dominating the scene. Try to imagine the same picture without these two elements. Would it have been as interesting?

● BELOW The addition of a polarizing filter for this shot gives the sea a translucent quality. In order to check the effect of a polarizing filter when using an SLR camera, rotate the filter while looking through the viewfinder, until the desired effect has been achieved.

SPECIAL EQUIPMENT FOR SEASCAPE SHOTS

1 A lens hood – this should be fitted at all times, whether or not beside the sea, but is particularly important in cutting down any unwanted reflections which may flare on the lens.

2 A polarizing filter – this makes the blue colours of the sky much richer, and enhances the clarity of any small white clouds. The filter will also change the reflective nature of the surface of the sea.

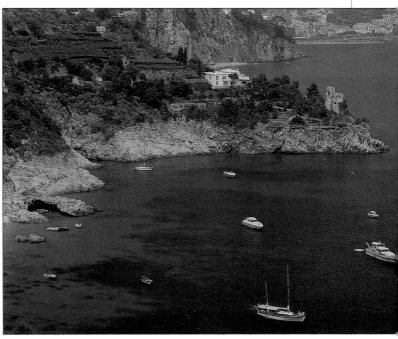

Lakes, rivers, streams or canals offer an entirely different variety of photographic opportunities from those found by the sea and in coastal regions. The surrounding areas are often reflected in the surface of the water, adding an extra dimension to the shot and reproducing what is often the most spectacular scenery twice over.

The same problems of measuring exposure encountered when taking seascapes also apply to pictures of large stretches of fresh or inland water; the exposure metering system may judge light as being brighter than it is because of the light coming from the expanse of reflective water. As with

● RIGHT This shot was taken from a rock set slightly out from the bank. The exposure used here was calculated to give maximum depth of field and the slowest possible shutter speed. This means that the rock in the foreground is very sharp while the water is blurred, emphasizing the speed at which the river is flowing.

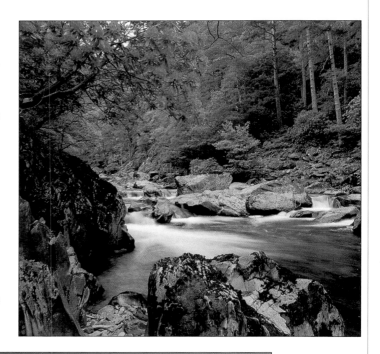

● LEFT If a shot is taken very early in the morning, the water surface is often quite still. This creates a perfect mirroring medium. The inclusion of the single cloud adds depth to the image as well as providing an extra point of interest, drawing the eye upwards as well as to the reflection in the water.

● LEFT Colour and detail are not always easy to find in the composition of a water shot. Here the canal boats add bright spots of colour in what would otherwise be a rather dull stretch of water. The trees help block out unwanted buildings and provide a neat frame for the picture.

sea shots, compensation must be made for this in order to avoid underexposure and ruined pictures.

Take care when choosing a viewpoint for water photography. Make sure the surface, especially of rivers or canals, is free of factory effluent, waste products and debris, unless this is the detail to be highlighted.

● RIGHT Choice of viewpoint is always of paramount importance when photographing water, especially where reflection is included. Here the dramatic picture of the reflected snow-capped mountain is altered by the plants growing beneath the water. Make sure there are no unwanted intrusions in the final shot.

SHOOTING STILL WATER

Water is usually at its stillest very early in the morning before the wind, if there is any, has begun to blow. If the surface of the water is completely still, the surrounding scenery reflected in it can produce a striking mirror image. Try mounting the final prints vertically instead of in the conventional horizontal fashion. At first glance the picture will be a striking abstract image and many unusual, and often amusing effects can be produced by a little experimentation with presentation angles.

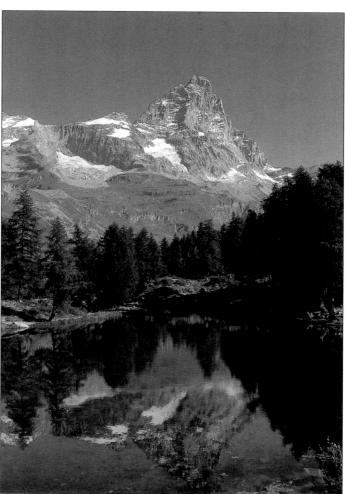

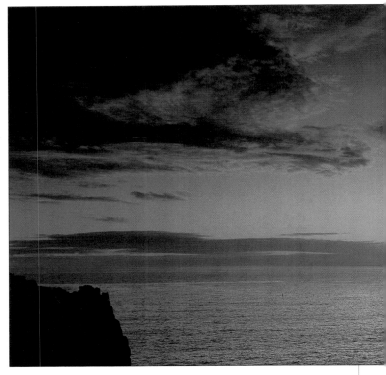

According to the time of year, the ever-changing light, weather conditions, cloud formations and seasonal changes provide an endless range of photographic opportunities when taking pictures of the sky. Although sunsets are a favourite subject for many photographers, not all sky shots need be taken at dusk, and in fact many of the most effective shots are captured at different times of the day.

The essential point to remember when photographing skies is to judge the exposure so that the important details, such as clouds, are recorded. A polarizing filter will help to darken the sky while retaining the detail if the shot is of a blue sky with puffy white clouds. A neutral density graduated filter could be used to similar effect or, for real drama, combined with the polarizing filter. As well as the neutral density graduated filter, a graduated colour filter such as a tobacco graduated filter can be added. This will turn the sky a sepia colour while retaining the natural colour of the land.

When photographing an area you know well, try to be in position early to take advantage of the changing light patterns and the different effects these have on the sky.

When shooting at sunset, be prepared to work rapidly, as the sun sets very quickly. Also be on the look-out for the changing colour of the sky. Once the

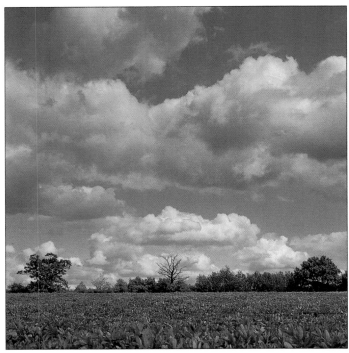

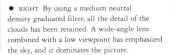

● RIGHT By using a medium neutral density graduated filter, all the detail of the clouds has been retained. A wide-angle lens combined with a low viewpoint has emphasized the sky, and it dominates the picture.

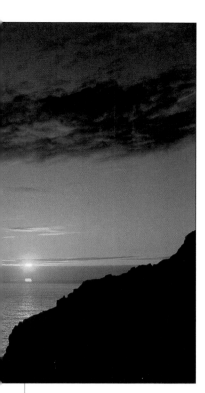

● BELOW Here there is an almost perfect mirror image of the sky captured in the surface of the sea. It is best to take this kind of picture when the water is very calm. Watch out for unsightly objects or rubbish floating in the foreground.

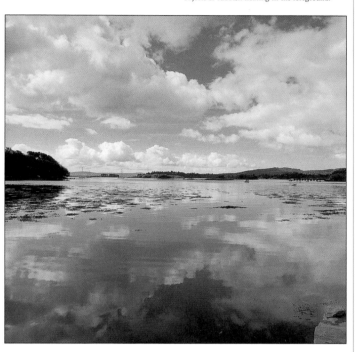

● ABOVE This picture was taken just before the sun sank beneath the horizon, and its light bathes the few clouds that remain in a golden aura. At this time of day a tripod is essential, as the exposure required will be quite long.

sun has set, the sky can deepen in colour considerably. At sunset watch for light playing on clouds; an aura of light from these will look far more dramatic than a clear sky. As exposures will be quite long at this time of day, a tripod is essential, and a cable release preferable.

REFLECTED SKIES

Skies that reflect into water, for example, make very good subjects. Either try to photograph the water when the air is completely still so that a perfect mirror image is achieved, or isolate a small area of water such as a puddle or pond to create foreground interest.

● RIGHT This shot was taken just before sunset. By using the small amount of water in the foreground, interest is focused on the sky and the composition greatly enhanced. The backlighting on the ripples of the wet sand has added texture. In a situation like this, carefully consider the reflective surface from various positions to obtain the best viewpoint.

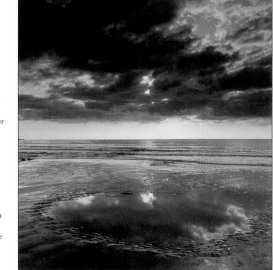

LANDSCAPE AND TRAVEL PHOTOGRAPHY

Buildings present the photographer with an inexhaustible supply of imagery. The most important part of photographing any building is the general composition. The weather can be perfect, the exposure correct and the time of day just right, but a badly framed picture will ruin everything. Here, equipment can be a great help:

● A telephoto lens will not only bring a distant building closer, but also, depending on the power of the lens, compress the overall view and so reduce the illusion of space between the main building in the shot and those that may be behind or in front of it.

● A wide-angle lens allows a close-up shot with an exaggerated perspective. A tall building such as a skyscraper can appear even taller if the camera is pointed upwards, because the verticals will converge.

● A shift lens allows the photographer to avoid converging verticals in situations where these are not wanted as part of the shot. A shift lens alters the axis of view without the need to move the camera, yet allows movement of the lens in relationship to the film plane.

Choosing the correct viewpoint is a vital ingredient for general composition. Position the camera so that there are no unwanted objects within the frame. This may mean simply moving a short distance or using a different lens. If the camera is fitted with a zoom lens, all that may be needed is a small adjustment in its focal length.

● ABOVE A telephoto lens was used for this shot of an isolated Scottish house; the top of the mountains that form the backdrop was deliberately cropped out. By composing a picture in this way, the isolation of the subject is emphasized and becomes a particular point of focal interest.

● LEFT A small telephoto lens of 100mm was used for this shot. This slightly compresses the buildings, making the composition very tight. Ensure that any vehicles or other unwanted intrusions have been moved before taking the shot, or try to stand in a position where they would be cropped out of the frame.

● ABOVE The railings around the church form a frame for this picture and produce a pleasing composition. Although a wide-angle lens was used, the viewpoint was close enough to prevent the church receding too far into the distance. The puffy white clouds help to break up the blue sky and enhance the composition, adding another visual element.

● ABOVE By waiting until dusk, a certain quality of light is captured; here the tower is bathed in a warm glow. The reflection of the building in the water helps to give a greater illusion of height. The use of a shift lens means that there are no converging verticals, yet the whole building still fits into the frame. Remember to ensure that when photographing modern buildings, light is not reflected off their exterior surfaces and into the camera lens.

BUILDINGS IN THE LANDSCAPE

Sometimes it seems enough to simply stand in front of a great building, point the camera and press the shutter, especially if the building is so famous that there does not seem to be anything to add. In many cases this may be true, but if everyone followed this path the results would be repetitive and tedious. There are always new ways of representing a familiar object: unusual angles, different lighting conditions, a section of an exterior. All these elements can enhance any photograph of a building.

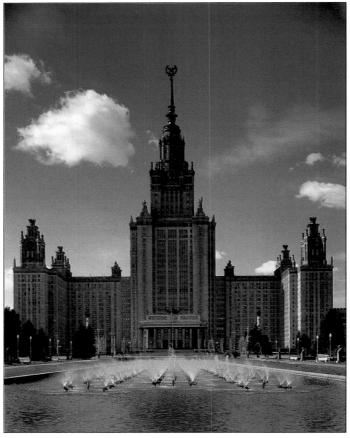

ATMOSPHERIC DETAILS

● Time of day is an important consideration when photographing buildings. If, from a chosen viewpoint, the sun rises behind the building, this could result in a hazy image, making the building look rather flat. If there is time, wait until the sun moves around, perhaps bathing the building in a warm afternoon light and creating strong shadow detail.

● Clouds can provide an added dimension. Sometimes even a radiantly blue sky will benefit from a few puffy white clouds above a building. Also, billowing storm clouds will add drama and perhaps a somewhat theatrical appearance to the shot.

● LEFT The New University in Moscow was photographed when the sun was at its highest and therefore illuminating the exterior evenly. A shift lens was used so that the full height of the tower could be included in the shot without needing to tilt the camera upwards. This would have caused converging verticals.

● LEFT Isolated in a mountain range, this white church stands out in a shaft of sunlight. This shot was taken after waiting for half an hour while a cloud obscured the sun; without the sunlight, the scene was flat and uninteresting. It is always worth waiting for changes in the light to obtain a better photograph.

● BELOW By standing to one side of this street, a rather ugly wall was cropped out. A medium telephoto lens, 135 mm, was used, and has slightly compressed the buildings and brought closer the fields in the background. This has produced a tight composition, with the emphasis on the row of housing without any unsightly distractions.

● ABOVE This shot was taken using a medium telephoto lens. The buildings in the foreground have been retained in the frame to enhance the cathedral of Siena as it stands majestically over them, dominating the skyline. The whole city is bathed in late afternoon light, which adds warmth and enhances the predominantly terracotta hues of the buildings.

● ABOVE The white puffy clouds, enhanced by a polarizing filter, hang gently over these adobe buildings at Taos, New Mexico, and help to provide extra detail. They also break up the otherwise somewhat monochromatic shot.

SHOOTING VERTICALS

Different lenses can completely alter the perspective of a building. Pointing the camera upwards, at a skyscraper for instance, will make the verticals converge. This can add greatly to the dynamic qualities of the image.

On the other hand, another building could be shown with converging verticals and might look distorted, seeming to be in danger of toppling over. Every building composition should be assessed individually.

A telephoto lens can be used to photograph a building from a distance. The building can be brought closer and the foreground compressed. This will give the impression of increased grandeur to the main building in the shot.

For more specialist photography of very tall buildings, a shift lens can be used. This allows a building to be photographed so that its vertical lines remain upright without needing to tilt the camera upwards. This would create converging verticals.

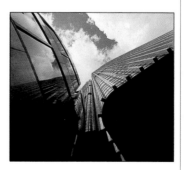

● ABOVE This picture of a skyscraper shows the extreme effect of converging verticals. By pointing the camera upwards, the height of the building has been exaggerated and its sides appear to meet at a point in the sky. A wide-angle lens has helped to emphasize this effect.

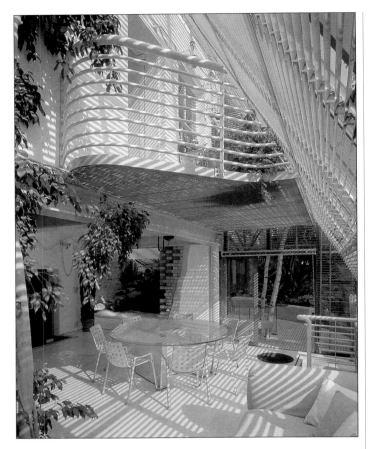

BUILDING INTERIORS

One of the main points to consider before photographing the interior of a building is the amount of light available. In the majority of cases, this is very little compared to that available outdoors. Our eyes are adept at adjusting to different light conditions – so adept that we soon cease to notice that certain conditions are in fact rather dull. With film, however, even relatively fast film, there is no such natural adjustment. The only way to record a usable image is to increase the exposure, or to light the interior artificially by using flash.

Many cameras have built-in flash or a flash attachment connected to the hot shoe of the camera or to a bracket on one side of the camera body. However, even with the most powerful of these flash units there still may not be enough light to illuminate the interiors of very large and grand buildings. Even where a fast film is used with available light, the result is very grainy and much of the shadow detail will be lost. A far better solution is to mount the camera on a tripod and use a long exposure. Of the pictures shown on this page, none was shot on film faster than 64 ISO, and in only one picture was flash used as well.

Inside great monuments crowded with visitors, some extra thought should be given to viewpoint so that the shot will not include other people. In some monuments, tripods are not permitted; in this case use a monopod or find a suitable surface, such as a pew, floor, table or window sill, on which to rest the camera.

● ABOVE This interior was shot entirely in natural light. The blinds were angled to let in as much sun as possible, while at the same time using them as a creative tool to cast interesting shadows. The result is a thoroughly modern interior bathed in bright sunlight.

● LEFT In this shot the window is illuminated by the daylight outside. This was not powerful enough to illuminate the walls inside without burning out the detail of the stained glass. By balancing the exposure of the flash on the walls with the light coming in through the window, an even exposure was achieved.

• RIGHT By using a fisheye lens, an unusual angle of the ceiling of Westminster Abbey in London has been achieved. Even though the Abbey was open to the public, tilting the camera upwards meant that people were cropped out. The day was overcast so there were no strong shadows on the sides of the buildings. This made the exposure relatively even, although long, and no other lighting was required.

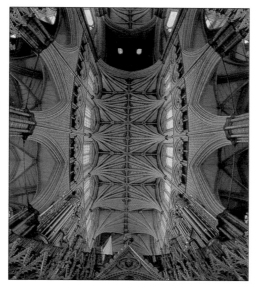

• RIGHT Flash is forbidden in the Long Room in the Old Library of Trinity College, Dublin, so available light was used. The shot was taken from the balcony to add a feeling of greater depth. If the shot had been taken from ground level, the camera would have to have been tilted upwards, and this would have led to converging verticals, giving the impression that the room was leaning inwards.

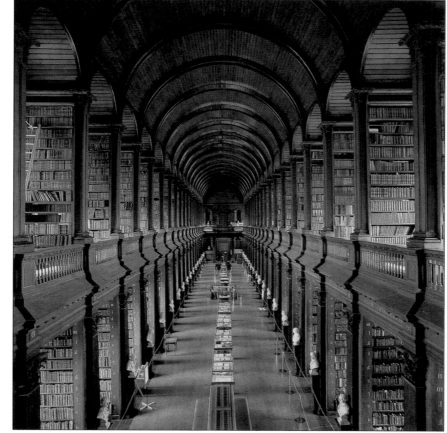

● BELOW By using extension rings, it was possible to get very close to this marigold. Depth of field was very limited and a long exposure was needed. This meant that the camera had to be mounted on a tripod and a shield used to protect the plant from wind, so that it did not move and blur the picture.

Plants provide good material for the photographer. It is worth considering not only exotic plants but also more commonplace varieties. Apart from colour, texture plays an important part in a striking image. All plants look their best at a certain time of year. If any plant is of particular interest, check when it is in season, especially if you have to travel any distance to photograph it.

Original effects can be created by isolating one plant in a mass of others, perhaps using the shallow depth of field afforded by a telephoto lens. There are other opportunities for unusual viewpoints; for instance a plant or group of flowers, or even trees in the foreground of a scene adds interest in its own right, and can also mask an unwanted object that would otherwise spoil the picture.

CLOSE-UPS

- If you are taking close-ups of flowers, depth of field will be very small, especially if you are using extension rings or bellows. You will therefore need to stop down as much as possible, and use a long exposure. If there is even the slightest breeze, the plant will have to be sheltered from it, or it will sway and blur the picture.

- Lighting can also be a problem when working so close. If you are using available daylight, you must take care not to cast a shadow from yourself or your equipment. A ring flash could be a useful accessory. This gives powerful but almost shadowless illumination. The flash tube forms a complete ring around the lens. Units for 35mm cameras are quite compact and do not weigh very much.

- A tripod is essential because of the length of exposures.

- Details of trees and other plants are also excellent subjects for close-up shots. The texture of bark can be fascinating, and different shots can be mounted together to make a striking collage.

- ABOVE RIGHT Look for the unusual. There will always be something of interest on a country walk. This whitebell was growing alone in a sea of ordinary bluebells. Careful use of depth of field has put the background out of focus, making the flower even more prominent in the picture.

- RIGHT The texture of tree bark can be very satisfying, especially when several varieties are mounted together. A whole series of pictures can be built up over the years. This applies equally to many other natural forms.

- LEFT These cacti in the foreground frame the view. Not only do plants in the foreground add to the general composition, but they can also be used to hide unsightly objects such as telegraph poles.

FLORA

● BELOW Safari parks provide ample opportunity for photographing wildlife. A telephoto lens is essential, as animals like this lion can only be photographed from a safe distance. Sometimes autofocus lenses do not work effectively when shooting through glass objects such as car windows. Manual focusing can overcome this problem.

One of the most demanding areas of photography is that of wild or semi-wild animals. Patience is required, and a certain amount of forward planning is useful if not essential. Despite the arduous nature of this area, the rewards can certainly make it worthwhile. While most people do not have the opportunity to travel to the regions best suited to photography of big game or endangered species, many may live within reach of a farm or a safari or wildlife park. Safari parks have many exotic animals, and with some peaceful species such as the zebra or giraffe it is sometimes possible to leave the vehicle and stand in the same area to take the shot with a medium telephoto lens of 100–200mm.

● ABOVE If taking a photograph in a safari or wildlife park or zoo, a natural image is perfectly possible as long as the background includes relevant vegetation rather than an unsightly man-made intrusion. A close-up shot can be obtained without frightening the animal by using a 100mm lens.

● ABOVE Small details are always most effective, especially when photographing fauna. These flamingoes look as if they are asleep, yet a careful look at the far bird shows that its eye is open. This shot was taken with a 250mm lens, since if the camera had been positioned any closer, the birds would have moved away.

PHOTOGRAPHING WILD ANIMALS

● Spend some time observing the behaviour of the animal; watch to see whether it is easily startled, or whether it appears to move in a constant direction.

● Try to select a viewpoint with an interesting background, without unsightly fences or buildings.

● Be patient. Calling or gesturing to an animal will probably cause it to run in the opposite direction. Upsetting wild animals can also be dangerous; however docile they may seem, it is important to remember that they are wild. It is best to avoid annoying both the animal and the farmer or ranger.

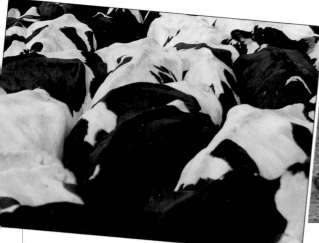

● BELOW Always be on the look-out for spontaneous pictures. A quick check for any unsightly intrusions is usually all that is needed towards the composition of such shots.

● ABOVE This shot of cattle was taken in close from a higher viewpoint. All detail has been cropped out, leaving only the black and white hides visible. This technique produces some effective graphic images that usually need a second look before the viewer realizes what the apparently abstract image is.

● RIGHT This shot was taken from a low viewpoint with a wide-angle lens. This produces a dramatic image of the sky. By getting into position and being patient, it is relatively easy to obtain effective and at times amusing shots of certain animals, whose natural curiosity means that they eventually come close to the camera for a better look. In this shot, the shutter was fired when the cow was about 1m (3ft) from the camera.

PATTERNS

The refreshingly new viewpoints that travel often provides may reveal scenes or details that appear isolated from their immediate surroundings. This might be due to the way the light falls or may be because of an object's texture, or a combination of both these elements. Such images need not be confined to a documentary record of a place, but can be used to startling creative effect. Examine the patterns created by an object or group of objects; often when such objects or scenes are carefully framed, they form an interesting composition. Sometimes the pictures have a very abstract appearance, or they may need careful viewing to see exactly what they are.

It is important to examine all the possibilities of a scene before taking the shot:

- Would it look best if framed symmetrically?

- Do the lines of perspective increase or decrease with the chosen viewpoint? If so, which is best?

- Is texture an important part of the picture? If so, does the light need to come from the back or the side to emphasize the texture?

- Would going in close help to achieve the effect better than being positioned further back?

- Would using a wide-angle or a fisheye lens create a more interesting or subtle effect? This can be especially striking when looking up at the ceiling of a building, for instance, particularly if all the horizontal and vertical lines have been carefully aligned.

● RIGHT Consider using prints or transparencies in a collage of different patterns. Try reversing one of the pictures and butting it up to one that is the correct way around.

All over the world, events take place that are worth a special journey. One such is London's Notting Hill Carnival, the largest street festival in Europe. People flock from far afield to see the parade, dance and share the street parties. Some come for that reason alone; others as part of a wider tour of the city or the country.

GETTING IT RIGHT
If you decide to make an event the high point of your trip, a little planning will avoid disappointment. Make sure you arrive at the right time: this may sound obvious, but events do not always happen on the same date each year, especially if they are associated with a movable festival such as Easter (which also happens on a later date for the Orthodox Church).

Take plenty of film. This will help to keep your pictures consistent, as they will all be from the same emulsion batch. With film bought locally you can never be sure how long it has been lying around in the shop, perhaps exposed to damaging heat. Professionals keep their film refrigerated. You cannot take a refrigerator with you, but at least you can keep your film as cool as possible.

CHOOSING A THEME
At huge and varied events, it is difficult to get just one picture that says everything. That is not to say that you should not look out for such a shot. A better approach might be to shoot as much as you possibly can, and to assemble these pictures as a montage on a particular theme, or a diary of events. Themes could be faces, floats, costumes, food, or the onlookers themselves. Many events last for several days, so you will have plenty of time to get all your shots.

SECURITY
Events such as a carnival are also a magnet for pickpockets. If you are carrying a case for accessories, keep it properly secured at all times. Be alert for children who beg you to take their picture. Unfortunately, it sometimes happens that, while you are concentrating on the shot, one of their colleagues is lifting your valuables.

● RIGHT A collection of images placed together effectively captures the atmosphere of London's Notting Hill Carnival. Small details can be placed next to wider shots of dancers and street scenes to convey the sense of colour and exuberance.

MAKING A
PICTURE
SERIES

When you are photographing an event, you need to consider how many different things are happening. Sometimes there is so much diversity that you are spoilt for choice. In other instances, the focus of interest may be narrow, and you will need to shoot from as many viewpoints as possible to give an informative account of the occasion.

PLANNING THE DAY
IN ADVANCE

It is always helpful to try to reconnoitre the place beforehand. Once the event begins, you might not be able to move about easily, especially if you are burdened with a camera case and a tripod. In such a situation, try to pick a spot that will give you a good view of the main action. Also find out when the

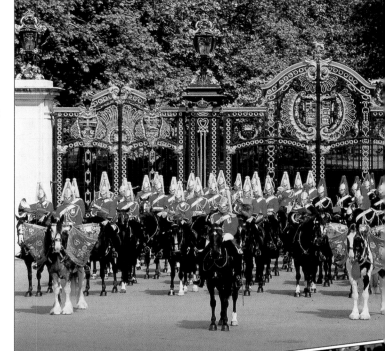

● ABOVE As well as taking a formal picture of these troops standing to attention, for instance, try to move in close so that either the detail of the uniforms is visible or so that the impression of them marching close together is conveyed.

● ABOVE A crowd scene completes the picture. However, instead of merely photographing a mass of people, try to find a point of focus such as the young girl on her father's shoulders.

● LEFT At an event such as London's Trooping the Colour, try to look for an unobtrusive background so that a group, such as these soldiers, stand out clearly. Sometimes extra height is needed for a particular shot: here the photographer stood on a strong camera case to gain an uninterrupted view over the heads of the people in front.

event is to begin, so that you can be there in plenty of time to get a good position at the front of the crowd. It is surprising how early people start to congregate for spectacles such as London's Trooping the Colour, shown here.

If you cannot get a commanding view, try to take a small, lightweight set of steps. Not only will you be able to see over people's heads, you may also get an unusual angle on the proceedings.

Also try to work out beforehand which will be the key shots that you simply must have. You could make a list just in case, in the heat of the moment, you forget what you meant to do. This may seem obsessive, but it goes without saying that hardly anyone makes a movie without a script!

For example, at Trooping the Colour you might plan to capture:
● The main participant – the Queen.
● A range of shots of the soldiers – individual guardsmen, and rows marching and standing to attention.
● The crowd itself.

This does not sound like a lot, but it is amazing how quickly an event can pass by and suddenly be over; it can seem like seconds if you have stood waiting for it for hours.

EQUIPMENT

Have a range of lenses ready, or if possible two camera bodies with zoom lenses – one could be 28–80mm, the other 100–300mm. In this way, you will be able to work quickly with the minimum of weight. A monopod will help you to brace the camera. This is especially important if the weather is dull so that a long exposure is needed.

● LEFT An essential shot at an event like this is the main participant – in this case, the Queen. Try to plan ahead and think where the person will be: here she is taking the salute before retiring to Buckingham Palace.

● BELOW By using a more powerful telephoto lens it is possible to photograph the other participants, such as the members of the Royal Family.

● BELOW By cropping the picture tightly –
a medium telephoto lens was used here – any
extraneous details can be excluded. The texture
of the wall provides a perfect canvas for setting off
the doorway, the shrub and the traffic sign.

Travel often has the effect of making us
more visually alert. Many things in our
day-to-day lives may pass us by without
us giving them a second glance.
However, a new environment provides
visual stimuli; to the photographer
these stimuli provide a new awareness
of photographic possibilities. Many
items around us may not be very
interesting in themselves, but gathered
together in a collection, perhaps as a
grouping of souvenirs from a particular
place and photographed in an attractive
way, a still life picture is created.

Still life arrangements have inspired
painters throughout history, and the
same inspiration provides photographers
with numerous creative opportunities.
It is a useful discipline to look closely
at, arrange and light a group of
inanimate objects. Sometimes these
arrangements already exist, and all
that is required is to see the potential
for an attractive shot.

● LEFT This is a good
example of a ready-
made still life. All the
objects were fixed to
the side of a barn on a
ranch in Arizona. This
shot frames them to
their best advantage;
no other preparation
was needed. To the
ranch owners, this was
just an assortment of
objects rather than a
creative arrangement.
It is often worth
looking around at
familiar objects to view
them with a fresh eye.

● RIGHT Some still life arrangements present themselves; this collection of African craft objects and furniture was lying in the corner of a room, lit by weak sunlight coming through an open window. A white reflector to the right helped throw back just enough light to illuminate the areas that were in shadow.

CHECKLIST FOR STILL LIFE SHOTS

● Should the arrangement be lit with flash, or is there enough available light?

● Examine the available light for any creative elements: does a shaft of light fall at just the right angle?

● Which angle would look best for the shot? Imagine the arrangement in the centre of a circle. Stand a certain distance from the objects and walk around them slowly, stopping at regular intervals. Every pause provides a new visual angle and a different shot.

● Which viewpoint? Consider the arrangement from eye level, as well as from above and below the objects.

● Every visual angle provides a different background: which one is most suitable and complements the objects most effectively?

● Consider the depth of field: should the background be sharp or blurred?

● RIGHT A large aperture was used here to emphasize the colour of these flowers by minimizing depth of field and throwing the background out of focus. The lines of the steps beyond are still just discernible, and they lift the background so that it remains a composite part of the picture without being too bland.

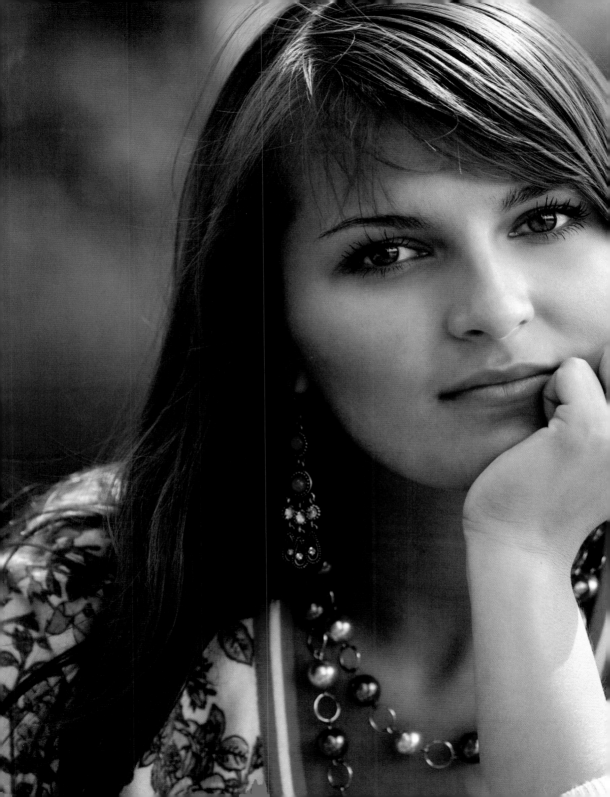

PHOTOGRAPHING
PEOPLE

● LEFT Probably more photographs are taken of people than of any other subject. There are so many different areas to explore through photographs: babies, children and older people, in groups, as individuals, in the studio or outdoors. With even the most basic equipment, good portraits are within everyone's grasp.

FORMAL PORTRAITS

Formal portraits do not mean that subjects have to sit or stand to attention so that they look stiff and uncomfortable. In the early days of photography, when exposure times were measured in minutes, people did have to sit very still to avoid blurring the picture. Photographers even used special clamps at the back of their sitter's neck and waist to brace them in position. Fortunately, these days are long past.

The most important thing in any portrait, formal or otherwise, is to capture the expression that best illustrates a person's character or status, or both. However formal the portrait might be, try to enter into a dialogue with the sitter. Discover a common interest, and the conversation will become easy and relaxed.

Even if the sitter is a complete stranger, try to plan the general nature of the shot in advance. It makes a bad impression if the first thing the photographer does after meeting the sitter is to stare hard at him, as if undecided what to do. But it is also important to plan wisely; it produces an even worse impression if, after a few shots, it becomes clear that the setting does not work, so that all the equipment has to be altered.

Often, time is of the essence. Some people, such as businesspeople and public figures, are very busy, and they may be under the impression that photographs can be taken as quickly as if they had walked into an automatic photo booth. Knowing what is wanted and directing sitters with flair and firmness can yield strong portraits in a relatively short time. The results will please them and enhance the photographer's reputation, and they are more likely to return.

● ABOVE Although this portrait of a young girl was taken in a studio, it is full of flair and vitality. An immediate rapport was struck up with her so that she felt confident and relaxed. Atmosphere is very important in any situation where there is close communication between photographer and model. It would be disastrous to start a session in an atmosphere of tension; this is as true in the studio as it is on location.

● ABOVE This man's face was lit with a very low-key light. This has heightened his features and given him an enigmatic expression.

● LEFT This studio portrait of a craftsman with his ancient musical instrument was shot in low light on a black background, emphasizing the features of the instrument. The feeling of precision, sensitivity and sheer art shine through.

● BELOW This portrait of the former Speaker of the House of Commons in London
had to be taken in a 10-minute session. His gown and wig might have made him
look intimidating and rigid; instead they signify the status of his position, and
are in keeping with a portrait that is both formal and interesting. Although the
Speaker appears small, this is in effective contrast to the grandeur of the room.

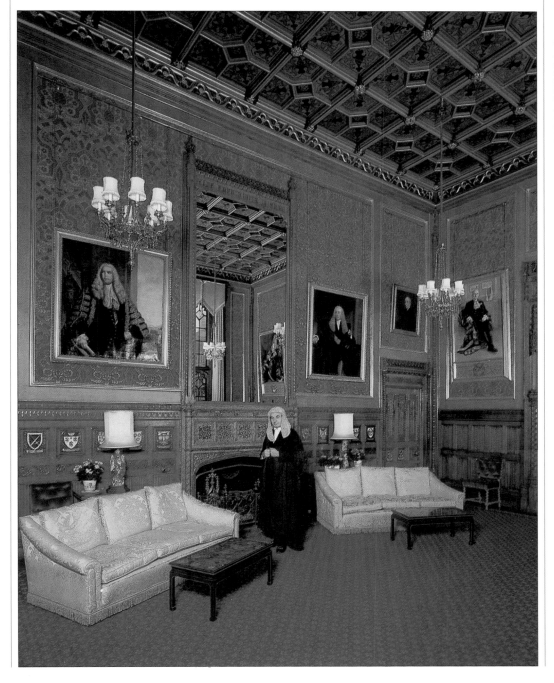

INFORMAL PORTRAITS

Many portraits work because they have an informal look that most people would call 'natural'. But even pictures like these need thought to make them successful. For instance, it is pointless to take lots of pictures in a casual manner if the exposure or focus are incorrect or the shot is badly composed. With a little forethought all these problems can be avoided, but at the same time there is no need to be so preoccupied with the mechanics of photography that it causes inhibition and the pictures become rigid and unspontaneous.

As with all aspects of photography, the most important thing is being so familiar with the equipment that all the controls become second nature. Once these are mastered, it is possible to concentrate on technique and become more adventurous.

This might mean experimenting with a different type of film. Try a high-speed one such as 1600 ISO. This will give very grainy results, but that is by no means an unattractive effect, as one of the pictures here shows (top right). Also, using such a fast film allows pictures to be taken in almost any conditions. The film can even be uprated to 3200 ISO. (Remember that if this is done, the whole film has to be shot at this rating, and when giving the film to the processing laboratory the technicians must be told that it has been uprated so that they can increase development time.)

A zoom lens, especially when combined with an autofocus mechanism, makes for faster work, since focal length can be changed without the need to swap lenses.

Ultimately, of course, it is the photographer's eye that seizes upon that good shot, however much advanced equipment may be available!

● ABOVE This picture radiates spontaneity, warmth and humour. It is a good example of capturing the moment, which swiftly passes when dealing with animals. Going in close helps the general composition and focuses attention on the woman and the chicken.

● BELOW Pictures like these come readily to the alert photographer. Always have the camera loaded with film to avoid wasting time. The person might move away – or in this case merely put on his socks and shoes.

● ABOVE An ultra-fast film, 1600 ISO, has perfectly caught this young boy's cheeky expression. The grainy quality of the film, far from being a drawback, adds to the picture. The day was dull and the area surrounded by trees, so it is unlikely that a slow film would have given an adequate picture. Especially with informal portraits, be ready to try something different, and do not be afraid to push film to its limits.

● RIGHT This couple was photographed informally at a barbecue. Using a 100mm lens makes them fill the frame without the need to go so close as to make them feel uncomfortable. The woman's vivacious smile contrasts attractively with the man's rather whimsical expression. The result is a natural look that is relaxed and charming.

● BELOW Even when going in close, it is still possible to achieve a relaxed portrait. This old man's weathered face is set against a plain background, which isolates and emphasizes his face. The ladder acts as a prop and introduces an informal element into the composition. The man's open-necked shirt adds a carefree element without looking untidy.

OUTDOOR PORTRAITS

Bright, sunny days offer good opportunities for taking portraits outdoors. But they can cause problems too. Bright sunlight can create harsh shadows. It can also make people screw up their eyes and squint, which looks unattractive. To get around this problem, try to move the person being photographed into an area of shade. Alternatively, turn them away from direct sunlight and use a reflector to throw light back into their face. If the person is wearing a hat and the brim is casting a shadow across their face, use fill-in flash to soften the shadow.

Another problem with outdoor portraits is that the wind blows people's hair about and leaves it looking messy. If possible, look for an area that is sheltered from the wind.

Be on the look-out for appealing backgrounds. This could be something with an interesting texture, such as a stone wall, or it might be a view into a landscape. If the background is not photogenic, consider ways of cutting it out. This can be done by going in close and framing the picture tightly, or by using a large aperture to throw the background out of focus.

When photographing groups of people, make sure that one does not cast an ugly shadow on another.

Bright but hazy days give an even, shadowless light, but in certain conditions and with some colour films the results may be a little cool. To alleviate this problem, try using an 81A filter. This will slightly warm up the tones.

● RIGHT A low viewpoint and going in quite close lets this boy dominate the picture. The surrounding landscape gives a feeling of spring, and the boy's expression is one of playfulness. When taking portraits outdoors, experiment with different viewpoints, otherwise all your pictures will have an air of sameness.

● RIGHT These
young girls form a
well-proportioned
group. They were
photographed with
the sun to one side and
slightly behind them.
This has avoided ugly
shadows under their
eyes, and stopped
any one of them
from shading another.
The background is
dominated by the pool;
the wall is unobtrusive
and does not spoil
the composition.

● ABOVE In this picture of an elderly woman,
a 100mm medium telephoto lens combined
with a wide aperture has put the background
out of focus. It has made the splash of green
behind the subject unobtrusive, but the colour
complements that of her headscarf. She is in
a relatively shaded area, so that her face glows
with an even, natural light.

● LEFT Children with
pets make very good
subjects for outdoor
photography. But
in both cases their
attention soon
wanders. When you
see either tiring or
becoming agitated,
it is time to stop. By
using a wide aperture,
the background in this
portrait is thrown out
of focus, so that the
two faces become
the centre of attention.

Taking good shots of people depends on many factors. One of the most important is where you take the picture from. It is difficult to set down hard and fast rules about this, and obviously it depends on the situation. But one or two general points are always worth bearing in mind.

If you choose a high viewpoint to photograph a person full length, this will have the effect of shortening them. But if you kneel down, you will exaggerate their height. A quick look in any fashion magazine shows many examples of this stance, with models who appear to have legs that go on and on. With young children and babies, it may be necessary to get down on the ground and choose an extremely low viewpoint for an effective shot.

When photographing groups or crowds of people, it is generally best if you can remove yourself from the throng and view them from a distance, or perhaps from above.

At a special event you may be able to emphasize the detail of a uniform or costume to make an individual or small group stand out from the rest.

When you go in close, the viewpoint you take can emphasize or exaggerate a person's expression. But remember that if you go too close with a wide-angle lens it is very easy to get distortion, which may not look too flattering.

Your next consideration is exposure. If people are moving about rapidly, TTL metering may be an asset, but when taking shots by this method, beware: the meter is reading for the general scene and not for a predominantly dark or light area, which may be the centre of interest of the picture. You may need to compensate for this to get a correct exposure.

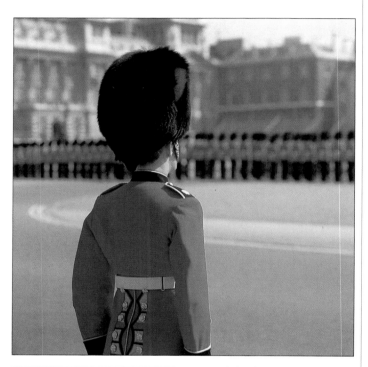

● ABOVE At formal events such as Trooping the Colour in London, it sometimes pays to look for a different angle as well as the more obvious shots. A viewpoint behind this guardsman emphasizes the colour and detail of his uniform. The line of soldiers can be seen out of focus in the background, which helps to concentrate our attention on him.

● LEFT Going low and looking up at this man's face has helped to highlight his features and expression. He is playing chess, and I wanted to capture his concentration. If people are wearing hats, be careful that the brim does not cast an unwanted shadow across their face.

● LEFT This shot was taken from ground level, lying in a similar position to that of the boy. The emphasis is on his face, and this has been exaggerated by going in close. Using an 85mm lens at this distance has helped to reduce distortion and has put the background slightly out of focus, so that nothing distracts us from his gaze.

● BELOW It is very difficult to get a general shot of people from ground level in a crowded place, such as a bustling market scene. This shot shows as many people as possible, with the stalls and some of the goods they sold, and was taken from a communal balcony. From here, a downwards viewpoint was obtained of the shoppers milling back and forth. The angle the shot was taken from makes a strong diagonal of the crowd, which enhances the overall composition.

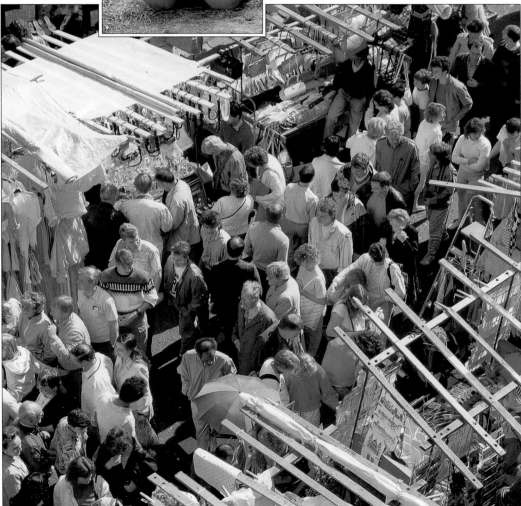

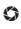
PHOTOGRAPHING PEOPLE

● ABOVE Here the glass panels of the door make an interesting background without becoming an intrusion. They are slightly out of focus but they are still identifiable. This makes the child's face appear to spring out from the doorway, as if one has captured her in a game of hide and seek.

A key element in shooting a portrait is the care given to the background. Yet, so often it is given very little thought and the finished photograph is spoilt by unwanted distractions. In some situations, such as in a studio, the background can be altered at will, and could range from a simple plain white or black backdrop to a more elaborate purpose-built set, or even a back screen projection.

When photographing people in their homes, at the workplace or outdoors, it is important to use the existing environment to the best advantage. This may mean including the work the person does – or even a relevant hobby or collection – without letting the subject become a secondary element within the picture. Positioning plays a key role in creating a background: thought should be given to where the subject of the portrait is to sit or stand, as well as the distance and angle of the camera in relation to both the person and the background. Choice of aperture is another consideration to be taken into account; a small aperture will produce a greater depth of field than a large one, and so more of the background will be in focus, which may well prove distracting.

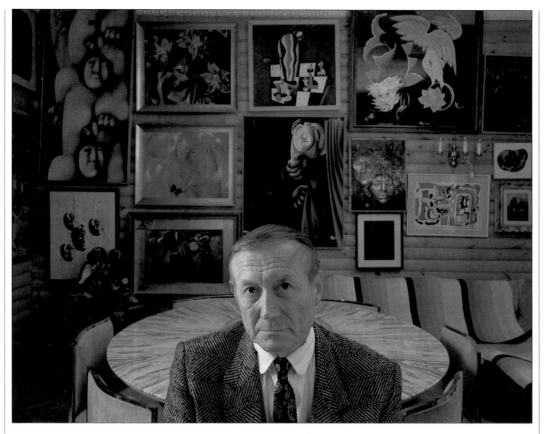

● ABOVE The Russian poet Yevgeny
Yevtushenko in his Moscow apartment.
Although the background is very busy, his
collection of paintings is highlighted as well as
him. By placing the poet in the centre of the
frame with the relative neutrality of his dining
table directly behind, he stands out and the
eye is immediately drawn to him.

● RIGHT Make sure the background does
not dominate the picture, and is not ugly or
uninteresting. The multi-toned red and orange
leaves in this picture add interest and colour, but
the girls' faces remain the centre of attention; the
background wall is slightly out of focus. When
photographing in bright sunlight, try to avoid
the presence of harsh shadows.

● LEFT This shot of a woman on a fairground
stall in Tenerife illustrates an instance where
the exception proves the rule. The background
dominates the picture and the stall-holder
looks completely lost. However, because of the
garishness of the display and its overwhelming
dimensions, the woman appears about to be
buried in an avalanche of her own wares –
adding a touch of humour to an otherwise
rather mundane fairground scene.

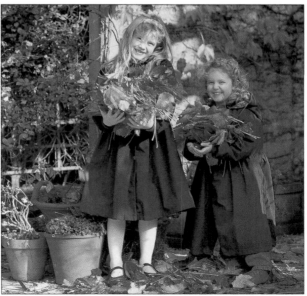

Props are items introduced into photographs that can either add something to the composition or tell us more about the person featured, perhaps providing information about a job or a hobby. Used successfully, props should enhance the picture without overpowering the person. In their simplest form, props might be an addition to the clothes someone is wearing – a hat or a flower, for instance. Sometimes a bunch of flowers placed in a vase near the subject will give a certain 'lift' to the shot. It could be that by placing people against a backdrop of their work, the item they produce or create becomes a prop in itself.

In a working environment there are endless possibilities for adding available props to a shot. These may take the form of a background or may completely surround the subject. If the people featured are in an active position, do not pull back so far that they become insignificant. In situations like this it is possible that the prop can subtly convey the atmosphere rather than becoming a visually dominating part of the picture.

For instance, if a man is involved in working with molten metal heated in a furnace, it would be the sensation of the intense heat rather than a prominent shot of the furnace that would say far more about the atmosphere. Going in close to the man and showing the heat reflected on his brow while keeping the furnace in the background, you could create an evocative composition.

As a photographer, always look for props in the immediate situation, and employ them in the same way as an imported accessory.

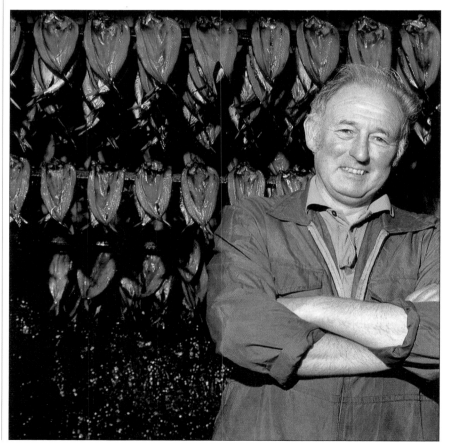

● LEFT This shot was taken in a 'smoker', the room in which kippers are cured. The room had jet black walls and was quite small. By placing the owner in front of several rows of newly smoked kippers, the fish themselves provided the props to illustrate his work.

● LEFT Upon
entering this
tobacconist's shop,
it seemed that the
entire place was full
of props. Positioning
the owner lighting his
pipe among his wares
added an extra visual
dimension to the shot,
as well as conveying
his character.

● ABOVE Costumes can provide effective props
in portraits; here the simple inclusion of an
unusual hat changes the character of both the
shot and its subject.

● ABOVE This woman lived in a small apartment.
She made exotic and expensive clothes, and the
purpose of the shot was to show her and her work
together. Since her work is so colourful, it was
decided to use it to fill the room and to cover
the kitchen worktop in the foreground. The
room takes on a swirl of colour but the woman
remains a prominent part of the shot.

Photographing people in their own environment can be very rewarding, especially when you are on holiday. Generally, strangers are only too willing to be in your shots – particularly if they are in an area where tourists are commonplace. However, if you want to photograph someone close in, you should always ask their permission first. There are several reasons for this:

- It is polite. If your manner is friendly, they will not feel threatened.

- Once they know they are the centre of interest in your photograph, they are much more likely to do what you

ask of them. This is important because, although they may be attractive and their environment interesting, they may be standing in a less than ideal place, and would be much better framed if you asked them to move slightly to one side, or perhaps on to a step. You might be able to get a better background by moving yourself to a different position, but if you creep about in a furtive manner, you are likely to upset them and make them uncooperative if you do finally decide to ask them to move. In this case, you will have lost the chance of a good photograph.

- Once you have gained their confidence, they may show you another area or aspect of their lives which you would otherwise overlook. This may well prove more interesting than the original scene.

- Having gained their cooperation and moved them into the position you want, look carefully at the light falling on their faces. Are they in bright sun which creates ugly shadows under their eyes and noses? Or is the sun behind them and shining into the lens? In either case, do not be afraid to move them again. You may never get another chance.

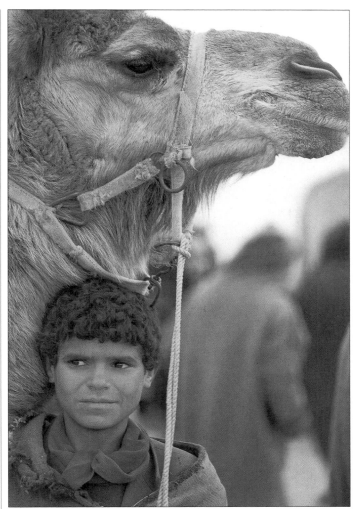

● BELOW This woman was cracking almonds outside her house. Her position was fine, but she was in strong shadow. By placing a small portable reflector to the right of the camera, just enough light was bounced back on to her. This is an example of a situation where a very bright background can give a misleading exposure reading.

● BELOW This shot is a good example of the advantages of taking people into your confidence. The shop was a good photographic setting, but inside, where this couple was, it was too dark. The couple agreed to move into the doorway where the light was better than within the shop, but the shot still needed something more, so they also agreed to hang sausages around the doorway. As a final touch, they are holding one of their whole hams. A bit of friendly discussion produced a shot which would not have existed otherwise.

● ABOVE Markets, like this souk in Agadir, Morocco, provide a wealth of opportunities for the alert photographer. This young boy was leading his camel through the throng of people gathered around the vendors. He is dwarfed by his camel, which has a typically arrogant expression. In situations like this, feel free to move around the person until he is in the best position with the light. The other people in the souk fill the background, but they are out of focus, so they do not intrude.

● LEFT Although the picture was taken from some distance, these security guards at the Museum of Art in Washington DC were well aware that they were being photographed, and they played to the camera. Their presence emphasized the monumentality of the bronze sculpture that serves as a backdrop. Always be on the look-out for such a juxtaposition.

If you study travel photographs you will be surprised at how often you can recognize the country, even a particular city, by looking at the people in the shots. This may be something as obvious as a shot of a guard outside Buckingham Palace or a portrait of someone in front of the Eiffel Tower. But other more ordinary forms of dress can also convey location – especially when combined with architecture.

Thanks not only to our own travels but also to television, newspapers and magazines, many parts of the world are now more familiar. Photographs which in the past would have been fascinating glimpses of exotic places are in danger of becoming mere clichés, but adding people to these views can lift them out of the ordinary.

Most local people do not mind having their photographs taken and some, such as uniformed guards, positively expect it. In all these pictures the people were unknown to the photographer, but in three of them it is clear that they were well aware of being the main focus of interest.

Always look out for the unexpected detail that gives the key to the location. It could be a sign on a door or a detail of a building, even something as mundane as an advertising hoarding. Clothing, as well as the overall lighting of the picture, gives a good idea of the climate of a place.

Think about viewpoint when taking pictures like these. It may be worthwhile to crouch down and take the shot from below. It will make people look more dominant than if you are looking down on them. Consider also whether it is best to have them in the centre of the frame or to one side. In the latter case, if you are using autofocus and your camera has an autoexposure lock, first point the camera at the people, semi-depress the shutter release and hold it down to lock the setting, then move the camera to the desired position and take your shot.

● ABOVE By restricting the depth of field, the buildings in the background have been put out of focus very slightly. This has helped emphasize the guard's vivid red uniform and the fine detail on his helmet, so that he becomes the focal point.

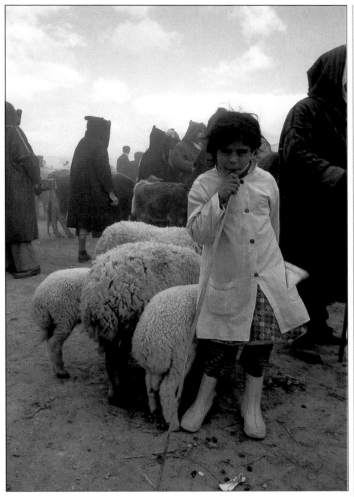

● ABOVE The girl is small, but a low viewpoint has made her the centre of interest. Always think carefully about the angle from which you take your portraits. The slightest change can alter the emphasis.

● LEFT These people in Orvieto in Italy made a diverse group. Shots such as this one can be used in a series of pictures of an area, to lend it human interest.

● LEFT This beer truck made an interesting background. Always be aware of unusual possibilities. The man was a complete stranger, but he was perfectly happy to be photographed. His clothing and the background positively shout 'America!'

People will add colour to travel pictures, especially when featured in shots presented alongside others concentrating on landscape, architecture or the sea. A series of pictures of the people of a locality can form a portrait of life in that region. To catch the spirit of local activities, go in close so that people are related to their work or environment.

When photographing strangers, politeness is the key. If people are approached in a friendly and reassuring way, only the most recalcitrant will object to being photographed. Remember, though, that in some

parts of the world it is inadvisable to photograph people – or even to make drawings of them. However strange such an opinion may seem, it is important to respect it. Remonstrating with people will only make matters worse. It would be far more productive to find someone in authority and use your best diplomatic skills to get them to reassure and persuade your subjects to give their assent. In most cases, such an approach, aided perhaps by a small gift, will win the day. A very effective method is to offer them a Polaroid portrait.

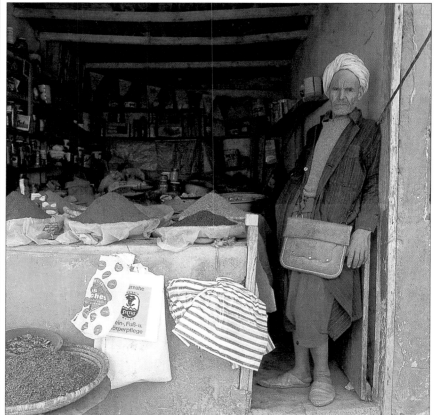

● ABOVE Being quick to spot a good shot and seize the moment is the essence of a good travel shot. This grape grower was seen driving his tractor laden with grapes down a country lane. He agreed to be photographed, and a series of portraits was taken in the late afternoon sun.

● LEFT Do not be afraid to take control of your shots, and direct people to the position where they will be seen to the best advantage. In this picture, the man was positioned in the doorway in order to keep the light evenly spread. Just moving someone backwards or forwards could make all the difference.

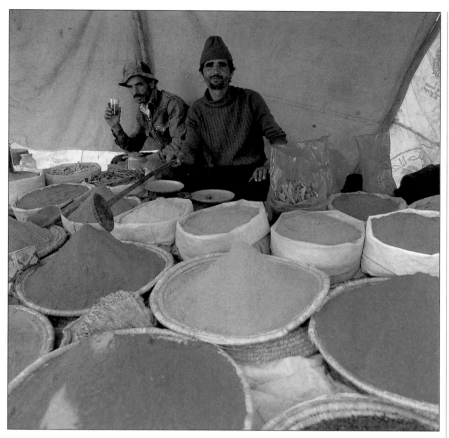

● RIGHT Using
a wide-angle lens
together with a small
aperture has given
good depth of field.
This means that the
spices are in focus
as well as the two
stall-holders. The
vivid colours of the
spices create strong
foreground interest
and lead the eye
into the picture.

● ABOVE This spontaneous portrait was taken
on a drive through Greece. The low viewpoint
makes the bale of hay look even larger. The
vibrant colour of the hay also makes an
interesting background for the boy.

● LEFT Careful
selection of colour will
say much about the
climate of a locality.
It does not always have
to be vivid; here the
colours are muted
but give a feeling of
warmth. This shepherd
was spotted by chance
on a drive through a
remote part of Sicily.
Although his sheep
were giving him and
his dog problems, he
readily agreed to be
photographed. His
clothes convey the
feeling of someone
who works outdoors,
and his hat indicates
that the climate is hot,
protecting him from
the strong sunlight.
Such ingredients in
photographs put across
a sense of place.

PEOPLE IN THE HOME

● BELOW Children provide good opportunities for pictures, especially if there is a camera loaded and ready. Even better, this should be a simple model that anyone can use. If it is loaded with medium to fast film such as 200 ISO, it should cope with most situations without flash being necessary. This picture was taken using natural light in front of a window, diffused by a net curtain.

Many people do not take pictures at home except on special occasions such as a birthday or Christmas. But there are many other times when opportunities for photographs present themselves, and often these can lead to excellent and memorable portraits.

One advantage of taking pictures at home is that people feel relaxed because

● BELOW This picture was taken from a high viewpoint because the room was rather small and as much of it as possible was required for the photograph. The woman is Frances Partridge, who was the oldest surviving member of the Bloomsbury Group when the shot was taken. She is surrounded by reminders of the group, including a portrait of Lytton Strachey.

they are in their normal environment. Another is that they are surrounded by objects that reflect their personality, which can be brought into pictures as props or backgrounds; these will reveal the varied aspects of their way of life, and their interests.

There is plenty of opportunity for spontaneous pictures in the home, especially of children. They may be doing the most ordinary, everyday things, but even these, when viewed through the camera, can be seen in a new light, and spontaneous actions captured. This is one reason why it is so important to be ready with your camera. If it seems laborious to get out

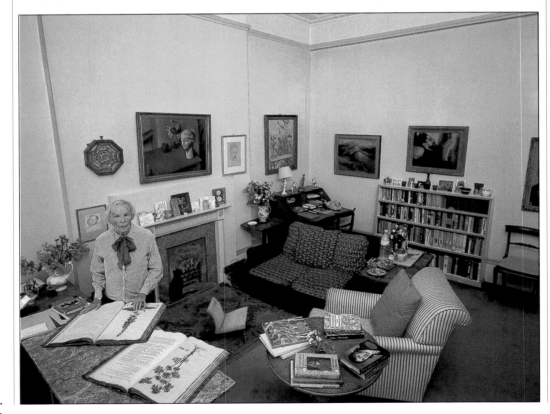

all your equipment, one solution is to buy an inexpensive compact camera for use around the house. This can always be kept loaded and ready to hand. It should have a built-in flash for quick shots in all conditions. In this way, there will never be a reason to miss a picture – and many pictures will be well worth the effort.

● BELOW Although this portrait is posed, it has a relaxed feel to it. The musical scores in the foreground hint that the subject is a composer, or at least that music is important to him. Two flash units were used. One was directed at the man and the foreground, and the other to light the area behind. These were balanced so that the scene outside the window was correctly exposed as well.

● BELOW This informal picture of a young girl at the piano needed flash. The piano keys make an interesting background. The high viewpoint adds to the picture's informality.

When travelling, good shots of people in their working environment can complement scenic pictures and add an extra dimension to a record of a journey. These pictures will often provide a more intimate insight into places visited, and show what is special about a particular area. They can be displayed in an album beside pictures of landscapes, buildings and family. Shots of factories or farms which offer tours,

waiters serving in a favourite restaurant, or a craft centre with unusual items – these may all capture the essence of the holiday or trip, and serve as a useful reference later on.

If the work that people are engaged in is very detailed, try to get in close so you can see what they are doing. Remember not to get in their way and so become a nuisance, or they may refuse to allow the picture to be taken.

If you are indoors and the light is low, flash may be needed. Try to bounce it off the ceiling or diffuse it. Nothing is worse than a harsh blast of strong flashlight that burns out the foreground but leaves the background dark and murky. Pay attention to the background too; does it add something to the shot? Does it provide any information about the work being done, or is it a useful plain backdrop?

● RIGHT The waiters and waitresses in this café in New Orleans are relaxing while off-duty. This type of shot shows not only people in their work environment but also helps to build up an overall picture of life in a particular town or city. Try to think ahead and decide which aspects of a trip will be the most memorable and descriptive.

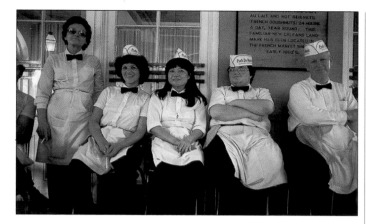

● BELOW These men are shown working in the malting room of a whisky distillery on the Orkney Islands of Scotland. By including their work implements in the picture, a clear image of their job is captured, as well as adding an air of spontaneous activity. The same implements also served as convenient resting posts while the men steadied themselves during the long exposure.

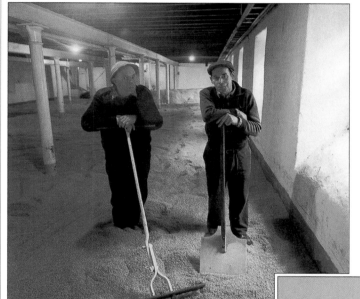

● BELOW Always look around to examine what props are available; these are usually part of the person's work and add extra visual interest to the picture, as well as providing information about the job itself. If the people to be featured in the shot seem shy, start by taking pictures of the surroundings so that they become used to a photographer's presence. Talk to them about their work. If they sense genuine interest, they will soon gain confidence and appear naturally relaxed in the picture.

● LEFT This photograph shows a rare professional lute maker. His work is very delicate and slow; one slip of a chisel and the whole instrument could be ruined. The shot was taken by a window using the available daylight that was filtering through. The intensity of the work is reflected in his expression. A 100mm lens was used to afford a clear view of what he was doing, while still keeping some distance from him.

PEOPLE ON HOLIDAY

More photographs are taken on holiday than at any other time. Obviously there is an incentive to get good shots of family or friends, not to mention new and interesting buildings and scenes.

There are a few points to remember before setting off: take plenty of film; and make sure that all equipment is in working order and that any batteries are fresh. For a beach holiday, take a plastic bag to protect the camera from sand, as this can ruin lenses. If any gets on the front element, blow it off – cleaning the lens with a cloth would have the same effect as sandpapering it.

Bright sunlight can cast deep and unattractive shadows under people's eyes, so it is important to think about portable lighting equipment. Flash can be used to fill in these shadows. Another solution is to use a reflector to throw light back on to the subject's face. At the seaside there are vast areas that reflect light, and it is easy to be misled by the reading given by a light meter. If possible, take a meter reading from a neutral area.

Look out for spontaneous shots. Candid shots, even of total strangers, can make a good picture – competitions have been won by such pictures, so be prepared for that instant shot.

Wherever the scene of the holiday, it is likely that there will be some event such as a fair or festival. These provide local colour, and should be used to advantage. They can include information about customs and traditions, thus adding an air of authenticity and situation to the shot.

● LEFT Young children make delightful subjects, none more so than this boy with his bucket. Be careful with exposure in seaside shots, since the glare from the sea and beach can fool the meter into underexposing the subject.

● RIGHT These children were on a Romany caravan holiday in Ireland. They were slightly reluctant to be photographed, but agreed as long as the horse and caravan were included in the shot.

● BELOW Although slightly posed, this picture of a young girl at a swimming pool is an attractive holiday portrait. The line of the white wall adds to the composition and makes an effective contrast with the blue of the pool. Shots like this can be fun, but it is important to work quickly so that being photographed does not become a chore for the child – boredom cannot be disguised.

● BELOW In the holiday season, most countries provide good set-piece events. Events can happen spontaneously, so be prepared. It is important to get the best viewpoint for a shot, as far as this can be done without being rude or pushy. Failing this, hold the camera above the heads of the crowd and point it at the action – it may be an outside chance, but it could work!

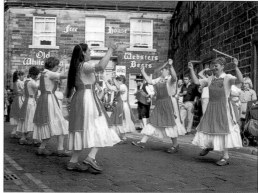

● ABOVE This picture taken from a high viewpoint shows what can be achieved by looking for a new and striking angle. Seen from above, the water is translucent. The dinghy adds a splash of colour. The two boys did not know they were being photographed, and the spontaneity of this simple shot adds to its effect.

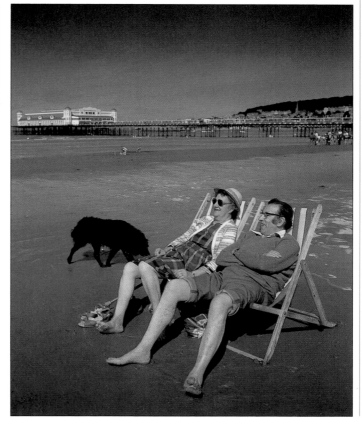

● RIGHT This couple fits in well with most people's idea of the British on holiday. The photographer did not know the people, but they happily agreed to be photographed. The picture is full of good-natured humour. Only a camera ready for instant use will capture the mood in this way.

A parent with their child is always a popular subject, and brings particular types of challenges to the photographer. Thinking ahead and working out solutions to these potential problems will produce the best results.

Use a photographer's eye to look for the best viewpoint and lighting to show the natural bond between parent and child. As in any situation when photographing more than one person, be careful that the parent's head does not cast a shadow on the child's face.

If working indoors, try to use the available light. This will be less distracting to the child, who may be alarmed if flash is used. If flash is necessary, soften the light as much as possible. This can be done by bouncing the light off a suitable surface such as a white ceiling or board. Alternatively,

put a diffuser over the light. This can be tracing paper or even a handkerchief. Take care here not to underexpose the photograph. The best way to avoid this is to use a flash meter, which shows exactly how much light is falling on the subject. If the parent and child are sitting by a window, a reflector can be used to throw some natural light back on to them.

When working outdoors, make sure that neither the parent or child gets cold. Not only is it uncomfortable for them, but they might be shown with red hands and dripping noses.

Above all, be aware that most children can only concentrate for a short time. This may mean working quickly. Conversely, a good deal of patience may be required to catch the child at the best moment.

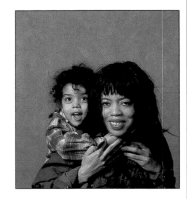

● ABOVE This photograph was taken in controlled conditions in a studio. Care was needed to keep the light from casting the mother's shadow on to the child. Placing the child behind the mother has created an informal mood, and it looks as if a game is in progress. Try to make your pictures look fun, especially in the artificial environment of the studio.

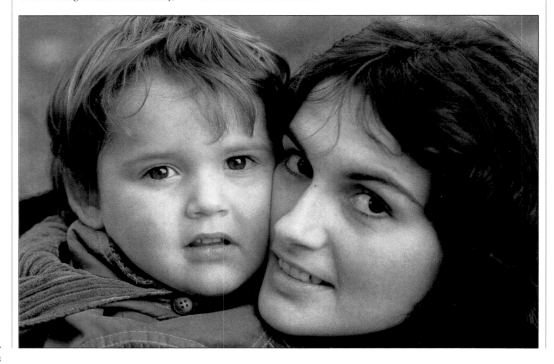

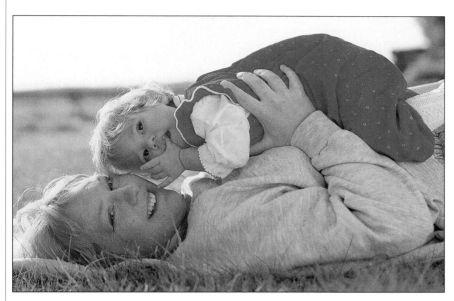

● LEFT This picture was taken against the light, and a reflector was used to bounce light back on to the mother and child. This has given a soft halo effect to their hair and made the picture look warm and summery. Asking them to lie down on the grass has further increased the air of a natural bond between the parent and child. The low viewpoint makes the viewer feel part of the picture.

● LEFT Going in very close has achieved an intimate picture of a mother and her son. It was taken on a chilly autumn day, and they are huddled together to give a snug effect. In such situations, take care that the child does not get too cold and become distressed.

● RIGHT Draping a white sheet over the window has created a very soft background. The parent and child were lit by flash softened by a diffuser. This has softened the overall effect even more, perfectly fitting the mood. In this case, the baby was fascinated by the flash light, and it proved a useful diversion for him. Using a 100mm lens allowed a comfortable distance between the camera and the subject.

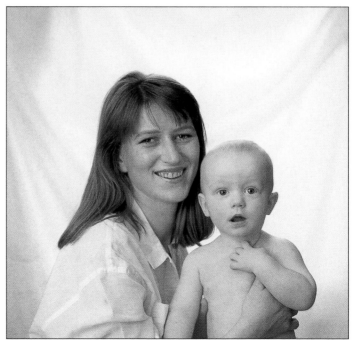

Very often when photographing groups of people there is always someone looking the wrong way, keeping their eyes shut or making a silly gesture or face. As a photographer, it will take all your expertise as a director to get everyone to do what you want them to do, when you want them to do it. The knack is to strike a happy medium between a jovial atmosphere and firmness. Of course not all groups of people that you photograph are going to be under your control. If this is the case, it is then up to you to find the right angle and be ready for the right moment. You will need to get yourself into a position where the light is at its best.

It might be advantageous in certain circumstances to photograph people

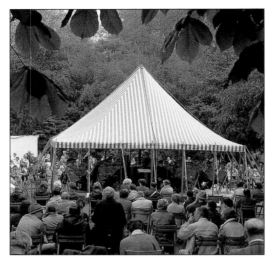

● LEFT By including the overhanging foliage from the tree in the foreground, a natural frame to the picture has been achieved. The people listening to the band have also added foreground interest. These details help to draw the eye to the main centre of interest – the group of bandsmen playing under the canopy of the bandstand.

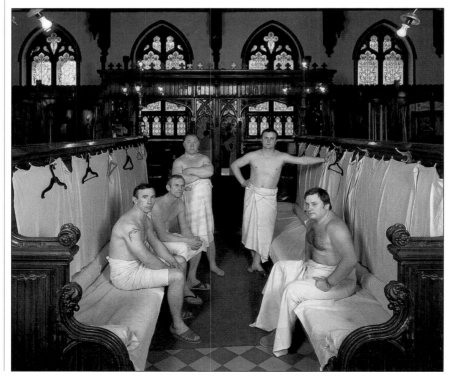

● LEFT This shot was taken in a steam bath in Moscow. The attendants were only too willing to pose for the photograph, and directing them to the required positions was quite easy. The lighting was a combination of flash and available light. The camera was mounted on a tripod and the shutter fired with a cable release. This meant that it was easier to keep an eye on the attendants' gestures and expressions, and to direct them to adopt the poses required. Because of the style of the building – it looks more like a Gothic church than a steam bath – a certain incongruity has been achieved.

unaware, but then if they discover what you are up to they may get annoyed or move away. Often if a group of people know they are being photographed, they will play for the camera and probably agree to your requests. If you are shooting indoors, the chances are you will be able to direct people to adopt the positions you want. Take a good look at their characteristics. Decide who is the most interesting so that they can be in the foreground or other prominent position.

If there are many people to fit into the group, position them or take a viewpoint so that no one is obscured by anyone else. Consider whether some would be better sitting while others stand. It would be an advantage to work with the camera on a tripod and use a cable release. In this case, you can position everyone to your liking. Also, when it comes to taking the actual shot, you can keep an eye on the group better from the camera viewpoint than looking through the viewfinder all the time. If you do use this method and your camera is set to autoexposure, you will have to cover the viewfinder. On nearly all cameras there is a small button that brings a shield over the viewfinder. This cuts out light entering the eyepiece, which would affect the camera metering mechanism and result in underexposure.

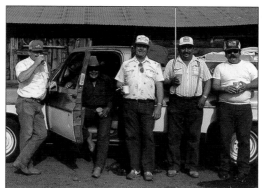

● LEFT These five men were photographed at a barbecue that was held at a ranch in Arizona. Either because of what they were drinking or because they were naturally confident, they had no inhibitions when it came to having their picture taken. Always be on the look-out for spontaneous situations, but take care that unwanted details are cropped out of your shots.

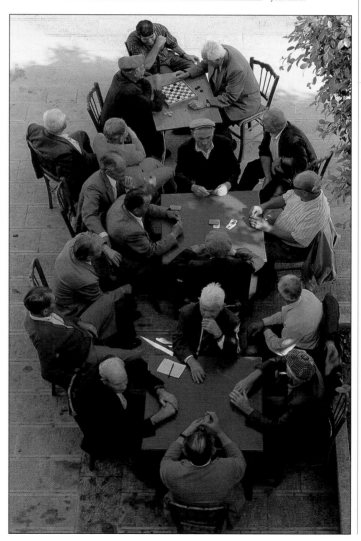

● RIGHT These men were playing cards on a terrace that was overlooked by a car park. It was a matter of chance that they were seen from this angle, but full advantage was taken of the viewpoint. Although the players became aware that they were being photographed, they were too absorbed in their game to care. With a large group like this, invariably someone will be looking the wrong way or making an unwanted gesture. Since it was not possible to direct them, several shots were taken so that a selection could be made.

CANDID SHOTS

● BELOW This is an example of being prepared for a spontaneous shot. The woman bending over the child makes the obvious comment on 'little and large'. However, the picture is taken in such a way that the woman's face is hidden, so she remains anonymous. The shot was taken using a 300mm lens that kept a good distance between the woman and the camera.

Candid photography is when people are photographed in a natural or unposed way and may be unaware of the camera. Being prepared is essential – carry a camera at all times and have it ready for use. Since the opportunity for shots may occur when the light is low and there is no time for flash, or when flash might be intrusive, try a medium-fast film such as 200 or 400 ISO.

If you do take a photograph quickly and the subject is still in position, see if you can shoot from a different viewpoint that may be better. Even if the person moves away altogether, you will still have that important first shot, but chances for improvement are usually available. Perhaps the best lens to use would be a 80–300mm zoom lens. This means that the picture can be framed in such a way as to crop out

any unwanted detail. It also means that you can get in close to the subject from some distance away without having to change lenses. In this way, you can work unnoticed without inhibiting the person or people and ruining the spontaneity of the situation. In candid photography it is often the look, gesture or position of a person that makes the shot.

It is an advantage to have TTL metering, preferably with spot metering facilities. This means a reading can be taken from the subject's face and you can expose for the skin tone. If the person is against a white wall or bright reflective background, then there is the risk of underexposure if the meter takes an average reading; this is because the background would be giving off the most light.

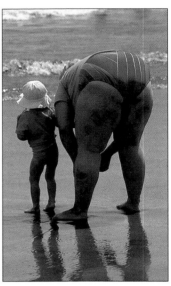

● LEFT This elderly man was quietly reading his book. After the initial photograph was taken, another viewpoint was found. This made a better composition, with the row of flower pots adding interest to his surroundings. Never think you have captured the perfect shot until you have exhausted all the possibilities.

● LEFT Always be on the look-out for a humorous shot, but do not try to make fun of older people in a humiliating way. Most people have a sense of humour and will see the amusing side of a picture that tells a good story.

● ABOVE Is it the unexpectedness of seeing a priest gambling that makes this candid picture a success? He was absorbed in selecting the winner in the next race and was oblivious to having his picture taken, even though he was quite close to the camera.

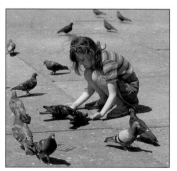

● ABOVE Standing back so as not to inhibit your subject usually makes for a better picture. A telephoto lens is useful in such situations, as it allows a frame-filling shot without the subject even being aware of the photographer.

● RIGHT Even when people appear to be unaware of having their photograph taken, a second glance may contradict this. This boy in a Tunisian market appears to be asleep, but a careful look shows that he is in fact watching from the corner of his half-closed eyes.

High-key pictures are those where the tonal range is predominantly light. These are not to be confused with high-contrast pictures, which are images that have extremes of tone with few if any mid-tones. In contrast, low-key pictures have a tonal range mainly from the dark end of the scale. Again,

these are not the same as low-contrast pictures, which are images that have a narrow range of tone – this is probably due to underexposure, and the prints will have a muddy look.

When a full tonal range is easy to achieve, why, then, take high-or low-key pictures? Here are some reasons.

High-key pictures can look very romantic, and sometimes achieve an ethereal quality. If the background to a picture is uninteresting or intrusive, it may be possible to fade it out by overexposing it. This may cause flare around the subject, but, handled carefully, even this can be used to

● LEFT This is a high-key picture. The model is bathed in soft, diffused light and placed against a white background. A soft focus filter has been placed over the lens, further enhancing the romantic look.

● LEFT This low-key picture was taken in a studio, using just one light. This was placed to the side of, and slightly behind, the model. A reflector to the left and just in front of him bounced back just enough light to give detail in his face.

creative advantage. High-key pictures can also portray freshness, a virginal quality, or the innocence of the newborn baby.

Conversely, low-key pictures can convey isolation or loneliness. They can be very atmospheric. The easiest way to create low-key effects in the studio is with what is known as a 'rim light'. The light is positioned slightly behind the subject. This creates a slight halo effect on the side that the light is coming from. Using a reflector or a fill-in light can give the shaded side of the face just enough tone. The result is an image with dark tones, but one in which the subject is easily discernible.

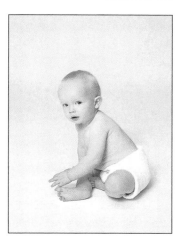

● ABOVE Although this young girl is wearing a medium-coloured top, the majority of the tones are from the lighter end of the scale. Her hair, backlit by the sun, adds to the high-key nature of the picture. A reflector was used to throw light back on to her face.

● LEFT This baby was photographed on a continuous roll of white background paper so that there is no line at the junction of the floor and the wall. A large 'softbox' light was used, and this has created a very high-key picture.

Many people are daunted by the idea of taking photographs in the studio. But generally speaking, the majority find that handling studio lights is an easy skill to pick up.

Look through various magazines which feature pictures taken in a studio. The lighting techniques are as varied as the subjects they light. In some only one light is used, in others five or more.

The least expensive light available is a photoflood with a reflector and stand. But many people find the glare and heat from such lights uncomfortable. An alternative is studio flash. The units work from the mains and are much

more powerful than a camera's built-in flash unit or one that fits on to a camera hot shoe. Each unit has its own power supply; some of the most powerful have attachments for additional flash heads.

As well as the standard reflector, there is a whole variety of different attachments that can alter the character of the light. These include large umbrella-type reflectors in white, silver or gold, which bounce diffused light on to the subject, giving a softer light than a standard reflector.

An even softer light can be obtained by using a 'softbox'. These come in various sizes, but all work on the same principle. The box fits over the flash

head. It has a highly reflective silver lining, and a diffusing material stretched over the front. Other diffusers can be stretched over the first one to diffuse the light even further.

Another lighting attachment is called a 'snoot'. This directs a thin beam of light on to the subject. It is not the same as a conventional spotlight, which has a broader beam that can be focused. Spotlights can also have inserts placed between the lamp and the lens, which throw patterns on to the lit area.

As with all accessories, special lights have to be used carefully and creatively. Used by themselves, they will not produce miracles.

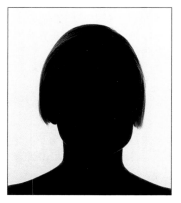

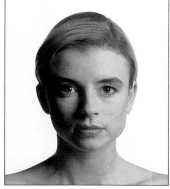

● RIGHT Here only the background is lit, to make it white and silhouette the subject. This technique has to be used with care, because an overlit background can cause flare. When framing the subject, take care that the light sources themselves do not creep into the picture.

● FAR RIGHT The use of just one light has lit one side of the model's face. This has left the other side of her face with dark, unattractive shadows, especially by the nose and eyes.

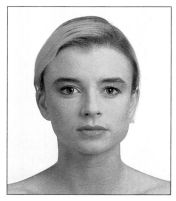

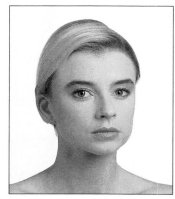

● RIGHT A 'fill-in' light has been introduced on the left side. This is less powerful than the main light. It has softened the shadows without making the face look flat. A reflector would have a similar effect.

● FAR RIGHT Another light has been used over the model's head to give more body to the hair. It was attached to a stand with a boom, an arm extending sideways. A boom allows a light to be brought close to a model without the stand appearing in the picture.

● The final picture has the addition of a white reflector placed under the model's face. This slightly softens the shadow under her chin, and to a lesser extent under her eyes.

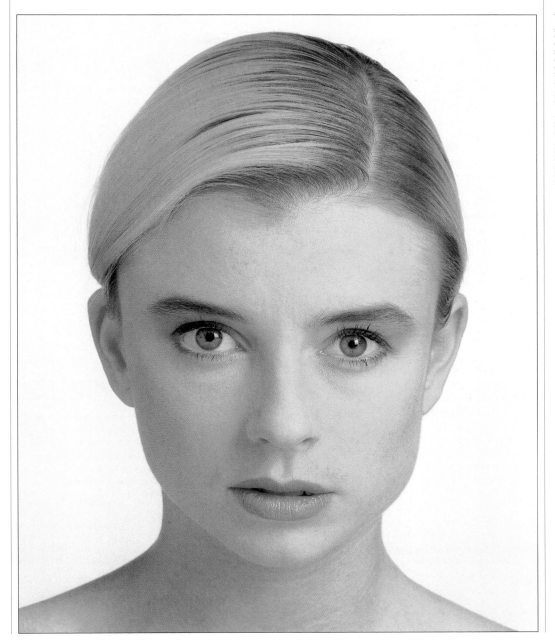

Getting the right exposure is just as important with black and white as it is with colour, but when making prints in the darkroom, there is far more latitude for altering the final image. 'Shading' and 'dodging' – that is, holding back shadows or underexposed areas of the negative, and selectively printing up highlighted or overexposed areas of the negative – can be done when making a print with an enlarger.

Before taking any pictures in a studio, try to work out the effect that is wanted. This will inspire confidence in the sitter. They will be put at ease if they see the lights and equipment being handled in a confident manner.

When using available light, some thought is needed to make the lighting work. When a flashgun or a portable flash unit is used, the light can be put where it is needed. If bright sunlight is causing shadows on the person's face, there are several choices. One is to move the person to an area of shadow where the light is more even. Another is to use fill-in flash to soften the shadows.

If shooting against the light, a reflector can be used to bounce light back on to the subject's face. If, on the other hand, it seems that a silhouette would make an evocative image, take the exposure reading from the light behind the subject.

● ABOVE A light was placed directly behind this young boy and pointed straight at him. The light was fitted with a 'snoot', which has narrowed the beam down to create the bright outline around his head. A weak directional light was used to illuminate his face. The picture was taken against a black backdrop.

When working outdoors, even if the light is bright, it can be interesting to use a film faster than would normally be chosen. This will give increased contrast and grain, even a 'gritty' look.

Always look for a new angle. Keep watch for an unexpected chance, and always have the camera loaded and ready. Remember that, unlike colour film, black and white is not affected by differences in light sources. Whether shooting in tungsten or fluorescent light or daylight, only the intensity of the light need be considered.

● LEFT For black and white film, look for lighting that gives a good tonal range, or an unusual directional light that will give a striking effect. Sometimes the simplest of images, such as these two children, is the best.

● RIGHT Photographing people in their homes in black and white can give strong and incisive images. Unlike photographing in a studio, however, there is not full control of lighting. Asking these five young girls to lie on the ground and look up at the camera has given a picture with a most unusual viewpoint. Do not be afraid to look for unconventional angles. This shot might have worked equally well if the photographer had laid on the ground and looked up at them.

● ABOVE Silhouettes make a striking effect. This brother and sister were photographed in the entrance to a cave. Exposing for the background has made the figures underexposed, and also the cave itself, which makes an attractive frame.

● LEFT These youths were allowed to position themselves as they wanted. A fast film, 1600 ISO, has given a grainy effect which suits their rather menacing air.

PROCESSING

AND PRINTING

● LEFT Once you have got your pictures back from the processing laboratory, it is time to edit them. Select one or two that give a good overall view, and decide whether any would be improved by being cropped differently. This sunflower image shows what is possible when choosing a very simple theme and cropping in closely.

PROCESSING YOUR FILM

Once you have taken your photographs, you will want to see the results as soon as possible. Although fewer high-street chemists now offer one-hour film processing turnaround, the service is still available in some areas. Check with your local stores to see what they can offer. Similarly, although specialist photographic shops are also thinner on the ground today, you may have one relatively nearby that can help you with film processing. Most are unlikely to be able to offer a one-hour service, but 24 hours may be possible.

Alternatively, a quick search on the internet will provide you with a number of online film processing labs. Of course you'll have to send your film over to them in the post and wait for them to send the processed film back, but many offer a free postal service.

Finally, you may find it useful to ask around at your local camera club to see if they have any recommendations. Camera clubs usually have a few members who shoot with film, and they will know of local film processing.

THE PROFESSIONAL WAY

A professional photographer has a close relationship with the technicians at his laboratory. It is in the interests of the laboratory to maintain the highest standards, because if it does not, photographers will not use it any more.

A professional laboratory can clip test film before the technicians process the whole film. This means that they will cut off the first few frames and process them. You can then check these and ask for adjustments to the rest of the batch. The processing can be adjusted in increments of as little as ⅛ of a stop (one stop is equivalent to the difference between f8 and f11, or between exposure times of ⅟₆₀ and ⅟₁₂₅ second).

WHICH LABORATORY?

A simple way to choose your processing lab is to pay them a visit. Are they accredited by Kodak or Fuji? Can you see the processing facilities, and if so, do they look clean and well organized? If there is someone at work, are they working in cotton gloves and a clean lab coat or similar? Have a chat to them, asking them about the kind of processing they do, whether they can push and pull your film, can they perform clip tests and make selective enlargements from your negatives, and make certain areas lighter or darker. By asking these questions you will be able to gauge the quality and knowledge of the lab, and feel confident in leaving your precious films with them.

Of course, for this to be worthwhile the film must be consistently exposed, and where the film is cut, one or two frames will be lost. There will also probably be a small extra charge for the clip test on top of the cost of processing the rest of the film.

PUSHING AND PULLING

If a film is underexposed, for instance if it is uprated, it needs to be given a longer than normal development time. This is called 'pushing'. Conversely, overexposed film is 'pulled' by being developed for a shorter time than normal. These techniques are common, but use them with care, as both of them cause a certain loss of picture quality: the harder a film has been pushed or pulled, the greater the loss.

More modern films, especially colour negative, are flexible enough to allow a bit of pushing or pulling. In fact, some films are sold on that very concept. Black and white film particularly has the ability to be pushed or pulled, as it easier to then bring the image 'back' in the print. But there really is no substitute for getting your exposures spot-on in the first place.

ENLARGED PRINTS

A professional laboratory will give you substantially better enlarged prints. You will be able to discuss how you want your picture cropped and positioned on the masking frame of the enlarger. If a transparency that is to be printed has a colour cast, you can ask for this to be corrected. If you want to darken or brighten an image, you can have specific areas of a negative or transparency shaded or printed up. This can be important if there is a quite large discrepancy between the tones in highlighted areas and shadows.

● ABOVE Colour or black and white, transparency or negative – before you commit yourself to having a whole reel processed, why not ask for a clip test to check the processing quality.

● BELOW You can check through old negatives using a light box to decide whether you have some photographs worth making into prints, transparencies or slides among them. Be selective, though, as this can become expensive.

● LEFT Regardless of the type of film or camera you have used, or whether you want slides, transparencies or prints, you can have some control over the processing. Quality processing can make a good shot excellent.

PROCESSING AND PRINTING BLACK AND WHITE FILM

One of the great things with shooting with black and white film is that it allows you to process your own film and make your own black and white prints. You can let a laboratory do either or both of these things, but they are really fun to do yourself, very satisfying and often cheaper. You really will never forget that first time you see your white bit of printing paper turning into a wonderful black and white photograph before your eyes in the developer.

The processes explained here can be done at home with the right equipment, but you may find it easier or preferable to go to one of the many black and white darkrooms that are available to hire, for example, at art colleges and universities.

If you choose to process and print your own black and white negatives at home, you will need a changing bag (or dark room) and an area with a sink and running water in order to process, wash and dry the films. Printing requires a larger space and one which you can make completely light-proof, but you can set up a temporary darkroom in your bathroom, or convert a room into a permanent darkroom.

If you are intending to convert a room at home, choose a small room with electric light and power, and cover any windows with blackout material. Make sure that no cracks of light are visible around the door – rig up a blackout curtain if necessary. Always ensure that you are not interrupted

at a crucial moment in your processing by putting a sign outside the door while you are working.

PROCESSING

To process a black and white film, once you have all the equipment together you first go into a completely dark room to load the film into the developing tank. Or instead of a dark room, you could use a changing bag. This is a large black cotton bag into which you place your developing tank, film and scissors in at one zipped end, and then insert your arms in through light-tight holes at the other. This allows you to load your film into the developing tank without going into a darkened room.

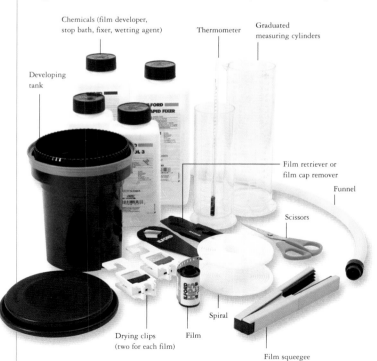

Chemicals (film developer, stop bath, fixer, wetting agent)

Thermometer

Graduated measuring cylinders

Developing tank

Film retriever or film cap remover

Funnel

Scissors

Drying clips (two for each film)

Film

Spiral

Film squeegee

USING A FILM RETRIEVER

A film retriever will normally have instructions on it. Insert the two 'tongues' into the film canister and then withdraw just the lower 'tongue'. Now rewind the film until you hear a faint click, insert the lower 'tongue' again and then withdraw both tongues together, bringing the film leader back out. (You can practise this as many times as you want on an unwanted roll of film.) This process ensures that light does not get to the film.

If you do not have a film retriever, you can, with the light switched off, open the canister with a film cap remover and then slide the film leader out of the opening. If you use this method, the next step must also be done in the dark.

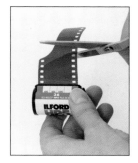

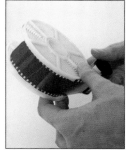

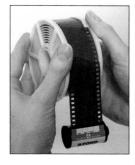

1 Work with the light switched on for steps 1 and 2. The film leader (the end of the film) should be sticking out of the film canister. If it is not, simply use a film retriever to pull it out. See box on opposite page.

2 Using clean scissors, cut the end of the film leader to remove the curved shape and gain a blunt point.

3 Now, in the dark room or changing bag, load the film on to the spiral. Small projecting pieces on either side guide you as to where to load the film. Move the film up and beyond the small ball bearings about 5–6cm (2in) along. You may find that practising this in the light, with an unwanted roll of film that you do not wish to process, helps.

4 With the film in place, pull about 30cm (12in) of film out of the canister and rotate each side of the spiral backwards and forwards between your hands to wind the film on to the spiral. Do not touch the film.

5 When you reach the end of the film, cut the film from the cassette, then, giving a few extra turns of the spiral, ensure the film is loaded correctly. Place the spiral into the developing tank and screw on the light-tight cover.

6 Mix the chemicals according to the instructions on the bottles, aiming to get the developer and other solutions to 21°C (70°F). (This is very important when using the developer, but less so with the stop and fixer.) Pour out the developer that you need, measure its temperature, then mix in water to make the temperature up to 21°C (70°F). So if the developer is 19°C (66°F), then the water should be 23°C (73°F), and so on.

7 Once all your chemicals are mixed, you can start developing the film. The time it takes to develop will depend on the combination of film and developer that you are using, so be sure to check your film or developer packaging. (If you have lost your packaging, it is very easy to find the information online.) Set a timer or clock, then pour the developing solution into the developing tank and start timing.

8 Hold the lid firmly and agitate the tank for the first 10 seconds, and then again for 10 seconds at the start of every minute of developing time. To do this, hold the top and bottom of the developing tank in your palms and smoothly turn it upside down, then right way up. After each agitation period, tap the base of the tank to release any air bubbles.

9 When the development time is almost up, pour the developer out of the tank (either into the sink or back into the bottle, depending on the developer you are using), so that the time is up just as you empty it. Immediately pour in the stop bath, agitating for about 5 seconds. Leave for another 10 seconds.

10 Now pour the stop back into the bottle, reset the timer, pour in the fixer, then start timing again and agitate as for the developer. The time for the fixer will depend on the type you are using, so read the bottle instructions carefully, but it is generally between 3 and 5 minutes.

11 Now wash the film. If you have a force film washer, attach it to the taps, remove the developer tank lid, insert the tube end into the developing tank and turn on the taps. Wash the fill for about 10 minutes at 20°C (68°F). Colder water will take a little longer to wash the film.

Another way to wash the film is to fill the tank up with water, replace the lid and invert 5 times. Then repeat this process, inverting 10 times, and then again inverting 20 times. Now pour away the water.

12 Use a wetting agent to help the water run off the film and avoid drying spots or streaks. Fill up the developing tank with water again, drop in a tiny amount of wetting agent, again reading the instructions for the correct amount. Lift the spiral out and then back into the water. Remove the spiral from the tank. Pull the end of the film out of the spiral and slowly unwind it completely from the spiral.

13 Attach a drying clip to one end of the film and hang it up. Run the film squeegee down the film to remove any water, and attach the weighted film clip to the base of the strip. Your film can now dry, preferably in a drying cabinet or over a tray to catch any drips.

14 Once your film is dry, cut it into strips of six frames with a clean pair of scissors, and insert each strip into a negative storage bag. This last stage is really important to keep your precious negatives clean and safe for the next stage: making your own prints.

PRINTING

Once you have finished processing your film, it is time to make a contact sheet, select the image you want, and then produce a black and white print. You will need wet equipment to develop, stop and fix your prints, and dry equipment to expose the paper. The procedure for making a contact sheet is described overleaf.

Many different types of printing paper are available, both resin-coated (RC) or fibre-based, multigrade and individually graded, neutral or warm-toned, and are available in a variety of sizes ranging from 10 × 15cm (3.5 × 5in) to 40 × 50cm (16 × 20in) and above. The simplest paper to start with is RC multigrade.

Although preparations can be done in the light, before you remove your printing paper from its package you must be under safelight conditions. This means using a red safelight that all darkrooms will have installed. This light allows you to see what you are doing, but does not affect photographic paper. You will also need to be under these conditions when you check the size and focus of your image.

● RIGHT When making prints, you will need the following dry equipment: an enlarger with a lens, an enlarging easel, photographic paper, multigrade filters, a timer or clock, negatives, a blower brush, and a focus finder.

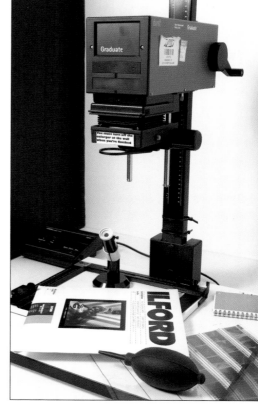

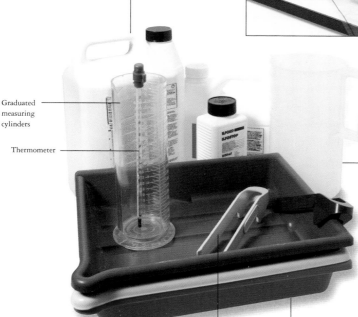

Chemicals (print developer, stop bath, fixer)

Graduated measuring cylinders

Thermometer

Large measuring jug (pitcher)

Tongs

Developing trays

● LEFT Wet equipment is needed for developing, stopping and fixing your prints. In addition to the equipment shown here, you will also need a funnel, a timer or clock, a washing tray with running water, and a drying rack or clips on a line.

1 First set up the wetside, with the developer, stop and fixer prepared according to the instructions given on the bottles. Pour the mixed chemical into the three processing trays. Always make sure you order them with developer first, then stop, and then fix. The washing tray/washing area should be after the fixing tray.

2 Set up the easel on the enlarger baseboard. Take the strip of film that contains the frame you would like to print, and place this into the negative carrier, shiny side up and back to front, with the frame to print in the window. Holding it firmly, use a blower brush to blow any dust off the negative.

3 Place the negative carrier into the enlarger, open up the enlarger lens fully (smallest number) and switch it on. Set the timer to focus.

TIMER AND FOCUS

The timer will have both a focus and time button or switch. Setting the timer will keep the enlarger light on. This is used when you check focus, but must be turned off when you place photographic paper under the enlarger.

4 Under safelight conditions, check the negative image projected on the easel. Raise and lower the enlarger head to get the image to the correct size on the easel. Raise and lower the lens to get sharp focus. Set the enlarging lens back to a 'middle' aperture such as f8, which will allow you to choose a usable amount of exposure time (not too short and not too long) and turn the timer focus button off. You can check sharp focus by using a focusing finder, a small device that allows you to check the exact focus of the projected image.

5 Set the timer to the time you selected from your test strip (see box), and make sure you have the correct multigrade filter in the filter draw (see box). Now that the enlarger is set up and the timer set, with the focus button off, place a piece of printing paper on to the easel.

6 Turn on the timer and the negative image will be projected on to the printing paper for as long as you set the timer to. It will then turn itself off.

7 Lift up the easel blades and, watching your clock, gently slip the now exposed printing paper into the developer tray. Most prints need between 1.5 and 2 minutes in the developer, but this may vary according to the instructions on the developer and printing paper packaging.

Immediately rock the print in the developer tray, then repeat a few times intermittently in the time allowed.

After a short time the magic begins, as a faint positive image begins to appear on your blank paper, quickly getting darker until the full image appears.

8 Once the correct development time is up, using tongs, carefully lift the paper at the edge (not touching the image), and transfer the paper into the stop bath and agitate with the gentle rocking movement as before. After between 10 and 30 seconds, depending on the printing paper used, transfer the print into the fix tray using the tongs. Gently rock the tray a couple of times and then leave it for between 2 and 5 minutes (again, the chemical and paper manufacturer instructions will guide you). The image should now be fully developed and clear.

TEST STRIPS

A test strip is used to work out how long the timer needs to be set to make the perfect print for any one negative. Follow the process laid out on these pages, but instead of placing a whole sheet of paper on the enlarging easel, you place a strip. Cut a piece of paper into a few 'strips' for just this use. Then set the timer to 3 seconds. Covering up all of the test strip with a piece of card held just above but not touching the paper, except for one area, expose the paper for the 3 seconds. Then move the card along a bit and expose again for another 3 seconds, and so on, to create about 5 strips. You will end up with the whole test strip being exposed in strips of 3, 6, 9, 12 and 15 seconds. Then process the strip as described, look at it in the light once fixed – don't worry about washing it – and choose which exposure time has worked best. You can then use this time to make the whole print.

9 Now transfer the fixed print into the wash. Keep the paper washing for the time recommended by the paper manufacture, then take it out to dry. Generally, paper must be washed for a minimum of 5 minutes, but 20 minutes is better as this will make sure every trace of chemicals is washed away.

10 You can now dry your print by hanging it on a rack or on a line. Once dry, your print is ready to mount, frame, put in your portfolio or simply gaze at.

CONTACT PRINTS

A contact print is one sheet of paper usually 10 × 8in (26 × 20cm) that shows a small print of all of your negatives in one film. From this contact print you can then decide which images you want to make a larger print, or perhaps show your selection of shots to someone. The chemical process is the same as described on these pages, but instead of putting a single strip of negatives into the negative carrier, you simply place all of your negatives on to a whole sheet of paper on the enlarger baseboard, cover with a sheet of glass to keep them flat, and turn on the enlarger for a given amount of time as discovered by doing a test strip.

Many areas of photography lend themselves to manipulation. Often such treatment goes completely against what is accepted as normal procedure; it might even be seen as a 'mistake'. Yet the results can be so exciting and dynamic that such mistreatment becomes a valid technique in its own right. Many of these techniques do not require any special equipment or even a darkroom: just a camera and film.

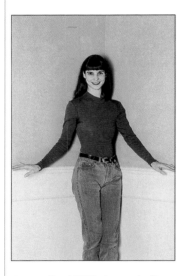

● ABOVE Here, 100 ISO colour negative film was rated at 25 ISO and given the E6 process normally used for colour reversal film. The skin tones are quite bleached out, and the effect is much less vibrant.

● RIGHT This picture was taken on 64 ISO colour reversal film rated at 12 ISO and 'push processed' (see opposite) half a stop in the C41 chemicals designed for use on colour negative film. This has increased the contrast and intensified the colour, especially on the floor and the yellow wall. A different type of film would have produced a totally different effect. Only trial and error will perfect this technique.

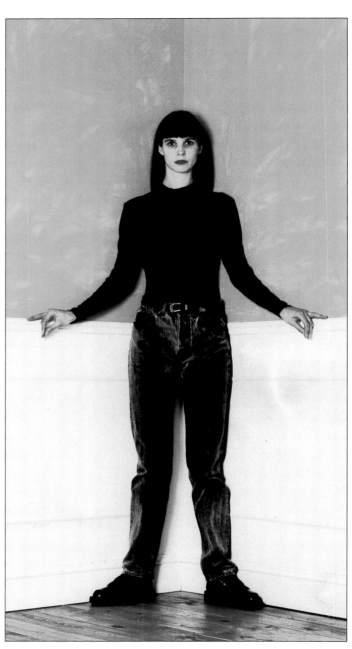

● LEFT A shot taken on black and white film and printed in the normal way.

Colour reversal film, which produces colour transparencies, is processed using a chemical solution known as E6. Colour negative film, which produces prints, is processed using C41. But what happens if reversal film is processed using C41 or negative film is processed using E6? The answer is the colours go crazy in a completely unexpected way, and can produce eye-catching results. Some films turn magenta, others bluish green.

Start with one type of film and see what happens. Study carefully what has happened to each colour. This may give a pointer to further interesting results. Does the film need more exposure – for example, should 400 ISO film be rated at 100 ISO? Should it also be 'push processed' – given more development time than usual? Only persistence and careful evaluation of the results will give the answer. In any case, the technique will give wild results, and these might include some great shots.

Another 'deliberate mistake' is to have black and white negatives printed on a colour printing machine. When a colour negative is printed, the light passes through three filters: cyan, magenta and yellow. Asking the printer to print with only one of these filters will give a positive print in that colour. Try each filter in turn, or try two of them – for example, magenta and yellow combine to make red.

The pictures on this page show some of the different effects that can be achieved when using different coloured filters when processing your film. Of course, to do this you need to establish a good relationship with your processing lab. Most labs pride themselves on trying to get the processing 'right', so you will need to make it clear that you intend to be experimental with your processing.

● LEFT The black and white negative printed on a colour machine, using only the yellow filter.

● LEFT The same negative printed through a magenta filter.

● LEFT Here the cyan filter was used.

● LEFT There are endless variations. This picture was printed through all three filters.

Montages can be made not only with prints, but also by sandwiching together transparencies made with colour reversal film. A reasonable-sized collection of transparencies will probably yield quite a few pictures that would make succesful images by being combined.

Pictures discarded for being slightly overexposed are likely to be just the right ones for this technique; so are correctly exposed pictures with plenty of highlights or a prevailing light tone. Do not try to put two dark subjects together: they will absorb most of the light, and the result is likely to be a muddy image.

Skies, tree bark, water, leaves, or even mud can be used as an overlay for a more defined image such as a portrait,

which should preferably be one taken against a white or pale background.

Try the combinations on a light box. When a good combination is found, fix the two transparencies together with a narrow strip of clear tape wrapped around the blank edge of the film, and put them in a plastic slide mount for projection or viewing. A really good image made by this method is worth having copied, although good copies of transparencies are quite expensive.

With some experience of sandwiching transparencies, it should be possible to see opportunities for shots that may not be too interesting on their own, but will be ideal as part of a sandwich. These can be made into a collection for use when a suitable pair presents itself.

While the aesthetic qualities of the transparencies will obviously be your first consideration, keep in mind that the resulting image will have a 'message'. Someone looking at the picture will try to find meaning in it – they may wonder, for example, if you have sandwiched a portrait of a woman with a shot of dried mud because you are making some comment about her. This might be construed an image with fairly negative connotations. The image of the woman with the leaves opposite is more positive, in contrast, and suggests she is a person who is in close contact with nature. There are elements of fantasy about them. The photographs of the wheel and woman with the mushroom macro may seem more abstract and experimental.

● ABOVE This girl was photographed against a white background. This image is combined with one of a dry river bed. Combining two images makes a statement and adds meaning to a picture.

● RIGHT The wheel of an army vehicle and a tree trunk are the two photographs that have been sandwiched together here. You can experiment endlessly with this technique to produce great abstract images.

● RIGHT Superimposing a portrait of a girl against a shot of a hedgerow has formed some interesting leaf patterns in this image.

● ABOVE A combination of a girl's face photographed against a white background and part of a car window covered in raindrops has produced this stylish image.

● ABOVE This interestingly textured picture shows a girl's face used against a photograph of a mushroom that was taken with a macro lens.

● RIGHT In this example, one transparency was of a group of logs that were photographed on end, and the other was a section of a dry stone wall.

Once you have got your finished prints in front of you, the final step is to edit them. How often you must have visited friends and been subjected to all their holiday snaps, with comments like, 'You can just see part of that church we told you about in the background,' or, 'This is a bit blurred but you can recognize John.' Not all their pictures may be like that, but they have not given enough thought to weeding out the unsuccessful or uninteresting ones. Even good pictures will make little impact if they are submerged within in a flood of bad shots.

Look at any magazine and consider the pictures that have been used. In a photo spread, the few pictures that have been printed will have been chosen from several rolls of film. In a newspaper or

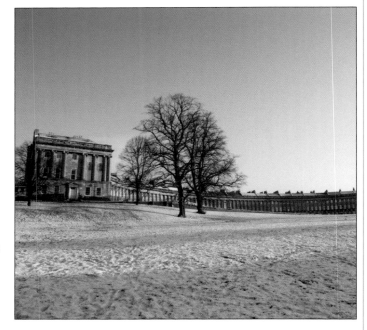

● RIGHT A classic view taking in the whole breadth of the architecture, but the frame is shot with a shift lens to prevent the vertical lines from converging.

● BELOW This shot contains no unwanted cars, people or other elements. The lines are straight and uncluttered. Compare this to the shot on the right.

● BELOW Here, there are cars just at the edge of the shot and a person has wandered into the picture, but they are too distant to be of any interest – they just add distraction.

● BELOW Before discarding a picture that may seem too dark, consider that a well-known subject can be more interesting if shot in an unusual manner, as in this silouhette of Bath Abbey.

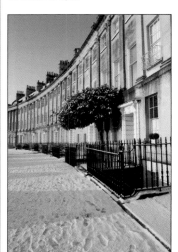

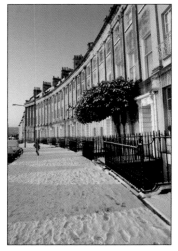

magazine, pictures of an event may have been chosen not just from many rolls but from the work of several different photographers.

When looking through your prints, begin by discarding those that are badly exposed. Next, look at subjects of which you have taken more than one picture. Select one or two pictures that give a good overall view. If there are others where you have gone in close, choose the ones that give the most interesting details. After this initial

editing process, decide whether any pictures would be improved by being cropped or differently framed when they are reprinted.

It is quite easy to select the best of a series of holiday pictures, but greater care is needed for a series of portraits or other studio pictures. These will have been taken in controlled conditions and will probably all be technically sound. Here you must look for the frames that show the model or subjects in the most flattering and engaging way.

● ABOVE A reel of film may give you many good shots, or sometimes, particularly when you are just starting out in photography, mainly bad shots. It is important to be selective about the ones you keep and have printed. Some pictures will not work and are better discarded. Once you have mastered the editing process, your pictures will make a much greater impact.

It may seem wasteful to discard so many pictures, but the results will be that people actually look forward to seeing your pictures, and the people you have photographed will be pleased with being seen at their best.

GLOSSARY

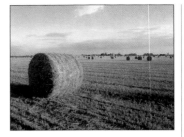

APERTURE
Opening at the front of the camera that determines the amount of light passing through the lens to the film.

APERTURE PRIORITY
Metering system in the camera that allows the photographer to choose the aperture while the camera selects the shutter speed.

ASA
American Standards Association: a series of numbers that denote the speed of a film; now superseded by the ISO number.

B SETTING
Indication on shutter speed dial that allows the shutter to remain open for as long as the shutter release is depressed.

BARN DOORS
Attachment that fits on the front of a studio light and allows the photographer to control the spread of light.

BETWEEN-THE-LENS SHUTTER
Usually built into a lens, this type of shutter allows flash synchronization at any shutter speed.

BRACKETING
Method of exposing one or more exposures on either side of the predicted exposure to obtain the best result.

CABLE RELEASE
Cable which allows the shutter to be fired with minimum vibration or camera shake; essential when using long exposures.

CAMERA MOVEMENTS
Found on large format cameras, these allow the photographer to move the front and back panels of the camera.

CASSETTE
Light-tight container for holding 35mm film.

COLOUR NEGATIVE FILM
Film that produces negatives for prints.

COLOUR REVERSAL FILM
Film that produces transparencies or slides.

COLOUR TEMPERATURE
A scale for measuring the quality of light in values of kelvin.

CONTACT SHEET
Method for printing negatives the same size as the film, so that the photographer can choose the images to be enlarged.

CYAN
Blue-green light; the complementary colour to red.

DARK SLIDE
Container for holding a sheet of film; used in large format cameras.

DAYLIGHT-BALANCED COLOUR FILM
Colour film that is balanced for use in daylight light sources at 5400 kelvin.

DEPTH OF FIELD
The range of distance – in front of the point of focus and beyond – that appears acceptably sharp.

DIAPHRAGM
The adjustable aperture of a lens.

DIFFUSER
Material placed in front of the light source that softens the quality of the light.

DIN
Deutsche Industrie Norm; German method of numbering the speed of a film, now superseded by ISO numbering.

DX (DIGITAL INDEX) CODE
Barcode on a 35mm cassette that contains information such as film speed. This is read inside the camera, and adjusts itself automatically.

EXPOSURE METER
An instrument for measuring the amount of light available, which can be read to indicate shutter speed and aperture.

EXTENSION BELLOWS
Extendable device that fits between the lens and the camera body, which enables the photographer to take close-up shots with a variable degree of magnification.

EXTENSION TUBES
Tubular device that fits between the lens and the camera body to enable the photographer to take close-up pictures. The degree of close-up available varies with the length of the tube used.

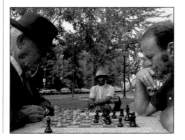

F NUMBERS
Scale of numbers that indicate the size of the aperture used, i.e. f2.8, f4, f5.6, f8, f11, f16 etc. Sometimes referred to as stops.

FILTERS
Coloured glass, plastic or gelatin that alters the colour of the light falling on the film when placed over the lens.

FIXED FOCUS
Camera that has no means of altering the focus of the lens; usually only found on the cheapest cameras.

FOCAL PLANE SHUTTER
Shutter method that exposes the film to light by using a moving blind in the camera body.

HIGH KEY
Photography where most of the tones are from the light end of the scale.

HOT SHOE
Electrical contact usually found on the top of 35mm SLR cameras; forms part of the camera's flash synchronization.

INCIDENT LIGHT READING
Method of taking an exposure meter reading by recording the amount of light falling on the subject.

ISO
International Standards Organization: the numbering system used to indicate the speed of a film.

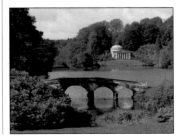

LIGHT BOX
An illuminated box used for viewing transparencies or negatives.

LOW KEY
Photography in which most of the tones are from the dark end of the scale.

MACRO LENS
Lens that enables the photographer to take close-up pictures without the need for extension tubes or bellows.

MAGENTA
Blue-red light; the complementary colour to green.

MONTAGE
Picture made up of a collection of other images.

PANNING
Method of moving the camera in line with a moving subject, such as a racing car. This produces a blurred background but keeps the subject sharp, thereby giving a greater effect of movement in the final image.

PARALLAX
The difference between what the camera viewfinder sees and what the lens sees. This difference is eliminated in SLR cameras.

PERSPECTIVE CONTROL (PC) LENS
Lens that can be adjusted at right angles to its axis. This enables the photographer to alter the field of view without moving the camera. Also known as a shift lens.

POLARIZING FILTER
Filter that enables the photographer to darken blue skies and cut out unwanted reflections.

RANGEFINDER CAMERA
System that allows sharp focusing on a subject by aligning two images in the camera viewfinder.

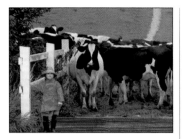

RECIPROCITY FAILURE
Situation where shots requiring exposures of longer than 1 second result in a loss of film speed; this leads to underexposure.

SHIFT LENS
Alternative name for perspective control lens.

SHUTTER
Means of controlling the amount of time light is allowed to pass through the lens on to the film.

SLR (SINGLE LENS REFLEX)
Type of camera that allows the photographer to view the subject through the actual lens, via a mirror that moves out of the way when the picture is taken.

STOP
Alternative name for the f number.

T SETTING
Indication on shutter speed dial that allows the shutter to remain open when the shutter release is depressed, and closed when it is depressed again.

TTL (THROUGH-THE-LENS)
Camera that assesses the exposure required by taking a reading through the camera lens.

TUNGSTEN-BALANCED COLOUR FILM
Colour film that is balanced for use in artificial light sources at 3400 kelvin.

ZOOM LENS
Lens with variable focal length.

I N D E X

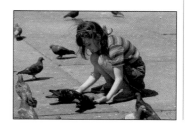

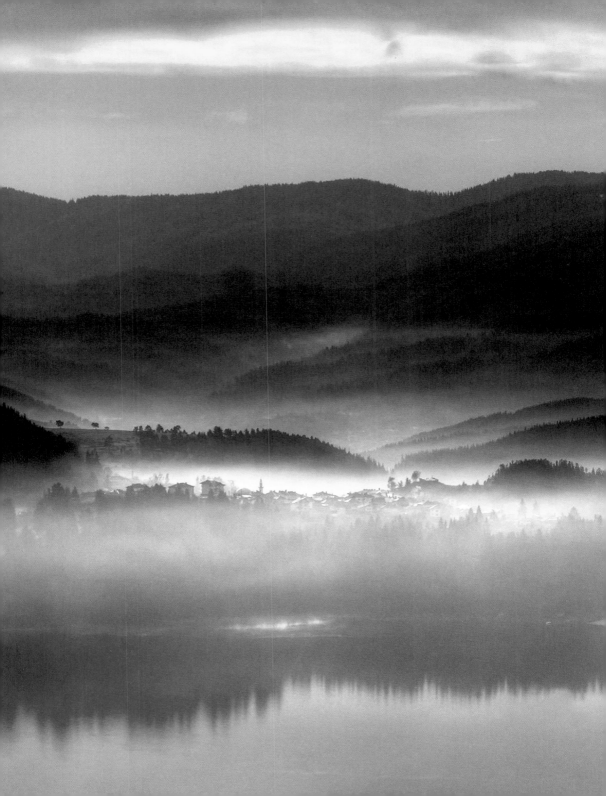